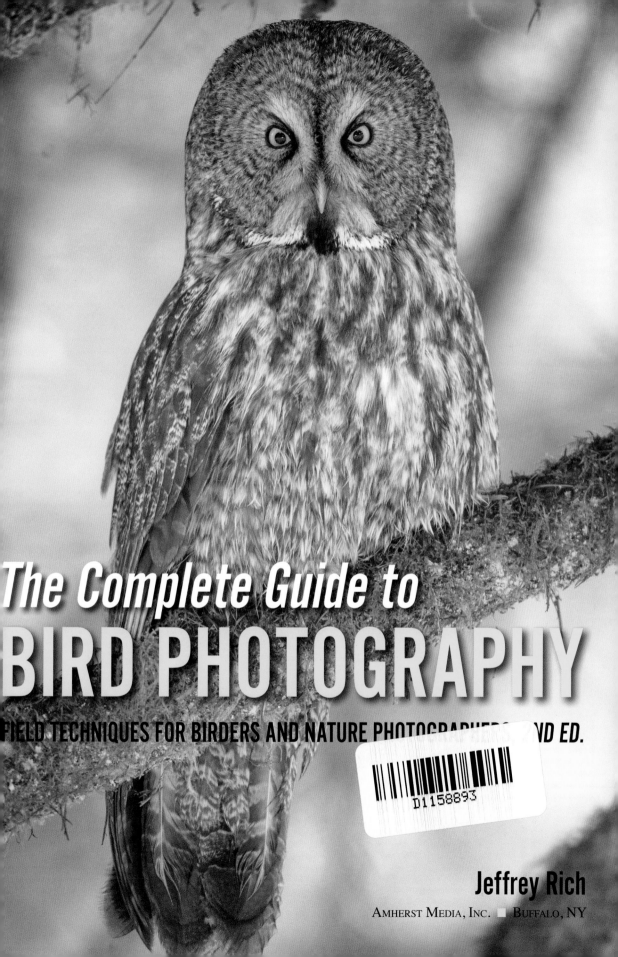

The Complete Guide to
BIRD PHOTOGRAPHY

FIELD TECHNIQUES FOR BIRDERS AND NATURE PHOTOGRAPHERS, 2ND ED.

D1158893

Jeffrey Rich

AMHERST MEDIA, INC. ■ BUFFALO, NY

Published by:
Amherst Media, Inc.
PO BOX 538
Buffalo, NY 14213
www.AmherstMedia.com

Publisher: Craig Alesse
Senior Editor/Production Manager: Michelle Perkins
Editors: Barbara A. Lynch-Johnt, Beth Alesse
Acquisitions Editor: Harvey Goldstein
Associate Publisher: Katie Kiss
Editorial Assistance from: Carey A. Miller, Roy Bakos, Jen Sexton-Riley, Rebecca Rudell
Business Manager: Sarah Loder
Marketing Associate: Tonya Flickinger

ISBN-13: 978-1-68203-358-6
Library of Congress Control Number: 2018939204
Printed in the United States of America
10 9 8 7 6 5 4 3 2 1

www.facebook.com/AmherstMediaInc
www.youtube.com/AmherstMedia
www.twitter.com/AmherstMedia

CONTENTS

About the Author

Jeffrey Rich graduated from Humboldt State University with a B.S. in Life Science Biology and a B.S. in Wildlife Biology, with an ornithology emphasis. He earned a master's degree in Science Education from the University of Texas and holds a California teaching credential in Life Science. He is currently a science and photography teacher at Stellar Charter School in Redding, California.

Jeff's photos and articles have been published in major magazines, including *Ranger Rick, Birder's World, Audubon, National Wildlife, WildBird, Sunset, Ducks Unlimited, Outdoor Photographer,* and hundreds of others. He has written a bimonthly column for *Northwest Travel Magazine* called "Watchable Wildlife," which accompanied one of his photos. He is also the author of *Bald Eagles in the Wild* (Amherst Media, 2018) and *Baby Birds* (Rio Nuevo, 2005).

Jeff has been leading photo tours and teaching workshops since 1991. These tours blend his background as a naturalist, teacher, and nature photographer to combine adventure with outstanding photo opportunities.

You can visit Jeff's website at www.jeffrichphoto .com and contact him at jrich@jeffrichphoto.com.

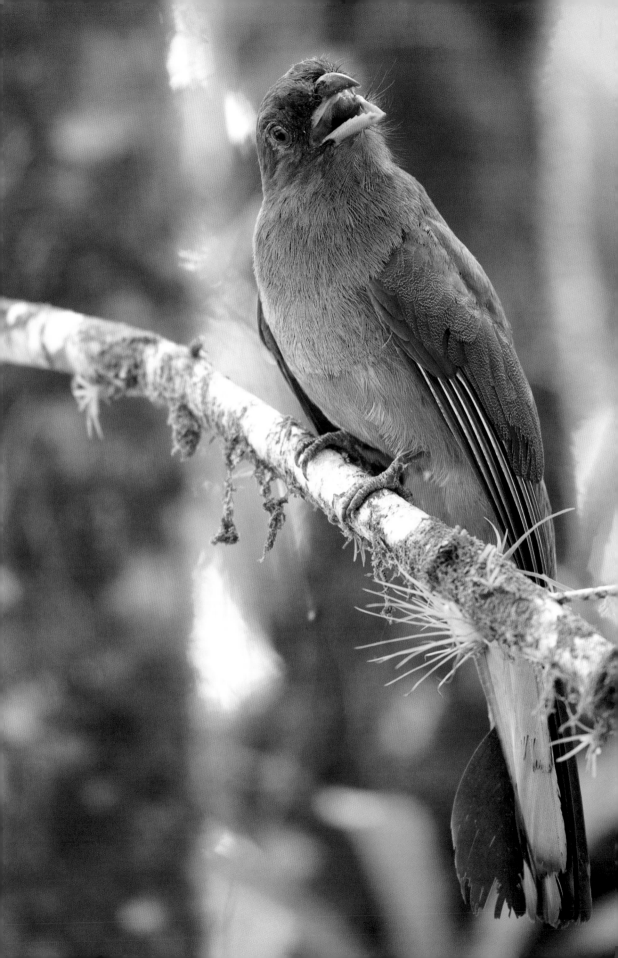

INTRODUCTION: WHY BIRDS?

Birds are beautiful, fascinating, and action packed. Bird photography can be done anywhere, from the edge of Antarctica to the remote depths of Borneo, from the big city to your own backyard. The fact that birds can be photographed anytime, anywhere, is one of the main attractions for me. There are many reasons to photograph birds, from simply identifying them to creating gorgeous artwork. Capturing the behaviors and actions of wildlife is one of the most challenging aspects of nature photography. Honing your skills to capture a beautiful image of birds in action is what this book is all about. When you master this level of bird photography, capturing all of the other, more static pictures will be much easier.

The Majesty of Nature

An added benefit of bird photography is time spent in nature, surrounded by the majesty of it all. This is the main reason I photograph nature. I enjoy the peace and harmony of being in the wild. I love wildlife of all types, and birds are my favorite.

Immersing oneself in the natural world can be healing, and I believe it is necessary for one's well-being. More people should

Barn Swallow taking flight. Wouldn't it be amazing to be able to fly?

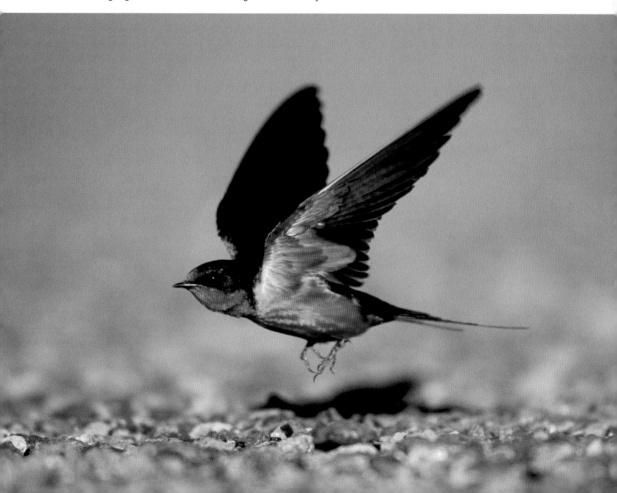

Here I am in the flowers, loving life. I lay down in a small impression where there were no flowers. No flowers were harmed in the process.

learn the value of being outdoors. It is vital for the human race to stay connected to the natural world. There is nothing like the peace and tranquility I experience while sitting in my floating blind, looking through the viewfinder, and focusing on nothing but making a great photo. I am "in the zone" when I am able to find something to share and show the world how beautiful Mother Nature is. It enhances my life. I believe it is necessary for my happiness and health. I am living a *National Geographic* special when I'm in the field. There is great privilege in sharing what I've learned and captured in-camera of the lives of my subjects. With this privilege comes the responsibility of putting the subjects' well-being ahead of any photographic situation. Respecting Mother Nature is critical to one's success as a nature photographer. Do everything you can to limit disturbance of the birds and other natural resources while in nature.

The thrill, excitement, and enjoyment of capturing a great image is the reward. Deciding what to do with your images afterward is a personal decision. For some photographers, the photography, being outdoors, and being focused on the beauty of nature is enough reward; others may want to see their images in print in *National Geographic;* some may want to write this book. Whatever your goals, working toward this high level of birding is a fulfilling adventure.

Wildlife is just one piece of nature photography, and birds are just one specialty within the scope of wildlife photography. A lot of overlap occurs in all forms of nature photography, and how you use any technique is limited only by your creativity. Technology has changed in my thirty years of photographing birds, but our feathered friends and the light that streams through a lens remain the same. I will share all I've learned over the years in this comprehensive guide. With the techniques in this book, you will learn to focus on capturing the best-possible image in-camera.

Birding is one of the fastest-growing endeavors in the outdoors, and photographing birds is one of the highest skill levels within the birding world. I hope this book will help all of those bird enthusiasts who are interested in making better bird pictures.

About This Book

This book is for anyone who wants to make professional-quality images of birds.

In these pages, there are plenty of tips for photographers, from beginners to pros.

My goal in writing this book is to help you capture the best-possible image in-camera. Although creating exquisite photographs at the capture stage is the goal, it is true that many digital images can be enhanced with postproduction work. Tips for achieving that goal will be shared as well.

top—Here is a Least Bittern catching breakfast. This bird is rarely seen, so capturing it with food was gratifying—especially since I've seen only one in my lifetime. **bottom**—I am always on the lookout for beautiful images, even a scenic. But when a bird shows up, even better.

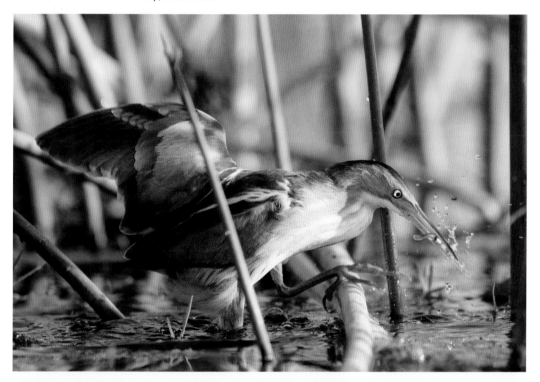

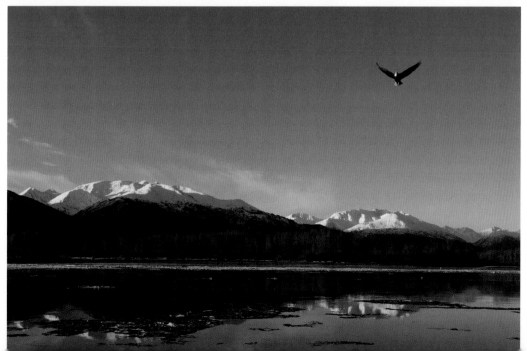

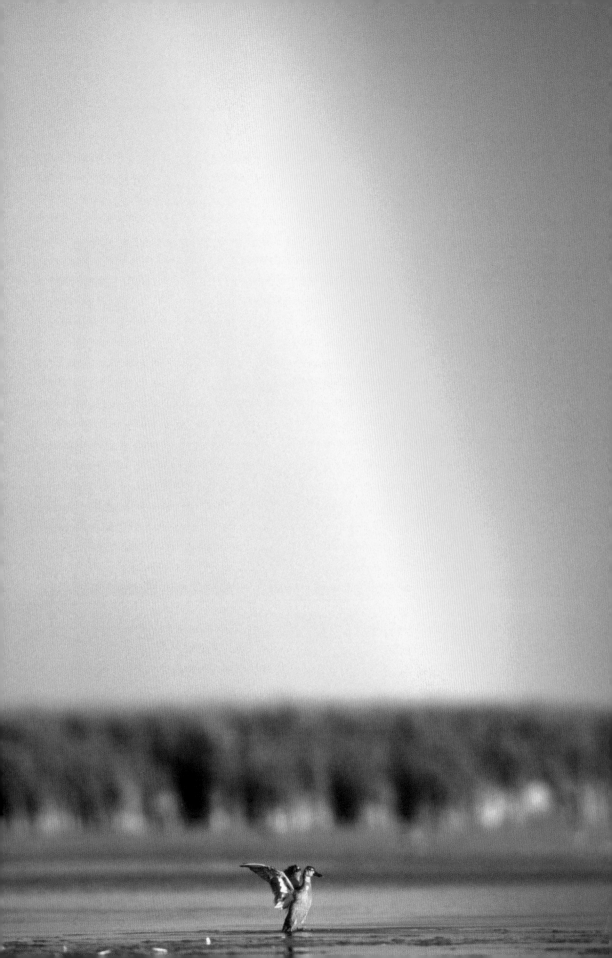

Cameras

Consider your goals regarding the images you will create before you choose a camera. Do you want to post your bird photos online, publish them in magazines, share them with friends and family, use them to teach the world, or . . . ? The camera is only a tool that determines the quality of the image. You can capture wonderful bird images with an automatic camera or a smartphone. Other factors to consider when choosing a camera are the price you can afford and the accessories that the camera can utilize.

If you are a birder or a photographer who simply wants to capture identification shots of birds, a spotting scope with a camera attached might be best for your needs. (We'll revisit this topic in chapter 5.) Many spotting scopes today have adapters that cameras can mount to. Even a PhD (push here, dummy!) camera (i.e., a fully automatic, one-button camera) can be coupled with a scope for good ID shots.

For professional-quality bird imagery, I recommend a high-end DSLR. These cameras produce high-quality image files with great resolution. These features allow you to crop your files for enhanced compositions without much loss in quality. Be ready to re-mortgage your house—a top-of-the-line DSLR costs over $5000! The main two brands used by professional bird photographers are Nikon and Canon, but by no means are you limited to cameras from these manufacturers. There are many choices, and there is a camera for every

need. My camera bag is full of Nikon gear, and my bodies are the newest professional DSLRs. Mirorless cameras are making an impression, too.

Technology is always changing. As of this writing, I recommend that those serious about producing artful bird photographs opt for a DSLR with continuous capture (motor-drive capabilities), a high-quality sensor with great quality at high ISOs (1600 and higher), and a fast-focusing motor for getting the action stopped and sharp.

facing page—Quality gear will help you create top-notch images. Mallard wing-flapping. top—My "paintbrush." I took my first nature photos in 6th grade. bottom—Birders searching for high-altitude rarities in Ecuador.

Selecting a camera that is the same brand a close friend uses would be beneficial also, as you can learn together and share equipment.

I shoot in RAW format. Doing so gives me a bit more control but requires more time in postproduction. I can save my optimized RAW files in JPEG or TIFF format if needed. You can shoot in JPEG, but the files are smaller, contain less information, and have a narrower tonal range. On the plus side, JPEGs may require less work in after-capture.

Once you have chosen the camera you want to use, read the manual carefully, start practicing, and practice some more. Get to know your camera. The more comfortable you become with it, the better your photos will be. Let your camera become an extension of your hand so you can think about composition and technique, not which knob to turn, when the action starts.

Lenses

Lenses are the most important part of your toolkit. Long lenses are heavy, but they are necessary for photographing birds. Go with as long a lens as you can comfortably carry, manipulate, and afford. If you aren't sure what works for you, take a trip to your local camera store and try out some long lenses. Can you put the lens on your tripod with ease, or is it too heavy? Can you comfortably carry it over your shoulder, or is it too cumbersome? Bigger is often better, but don't get a lens that is too big for you to use comfortably. If you do, you won't use it. Most professionals work with a 500mm or 600mm lens. I prefer the 500mm only because it is much lighter and easier for me to manage, carry, and use. My chiropractor is happier, too. The high-quality 400mm will work, but I wouldn't go any smaller than 400mm. Paying the price for the highest-quality lens in the beginning is better than buying an off-brand lens and being unhappy with the quality.

A 200–400mm lens comes in handy for photographing large birds in action and in flight. It will allow for more space around the subject. Some photographers on location will have their long lens on a tripod and the 200–400mm around their neck for quick-grab and in-flight shots. If you use a blind or are photographing tolerant subjects that allow a closer approach, a 300mm or 400mm lens can work. These lenses are usually more affordable.

When I started out thirty years ago, I had a 400mm f/5.6 Nikon lens. It was all I could afford, but it was lightweight, high-quality, and easy to handle. With a shorter focal length, I was forced to work from a

What's in Jeff's Camera Bag?

Nikon D5
Nikon D4
Nikon 500mm AFS f/4
Nikon 80–200mm AFS f/2.8
Nikon AF-S DX Zoom-Nikkor 12–24mm f/4G IF-ED
Nikon 200mm micro
Bogen/Manfrotto tripod with Arca-Swiss ballhead and quick-release plates by Really Right Stuff
Groofwin mount with Arca-Swiss ballhead
Nikon SB 5000 speedlight
Quantum battery 1+ for flash
SanDisk CompactFlash cards (16GB–256GB)
MacBook Pro 15-inch laptop
Portable hard drives, with as much memory as possible

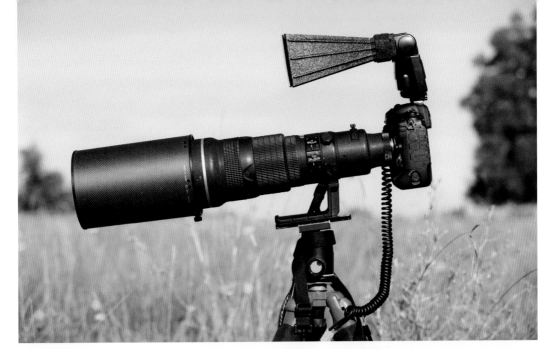

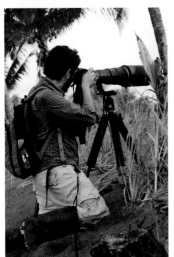
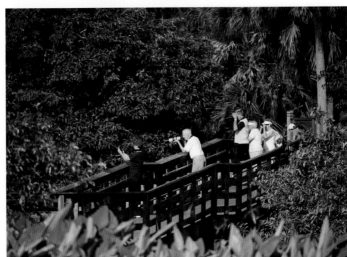

top—My Nikon D4 with a 500mm lens and a speedlight attached to a battery pack. **bottom left**—Photographer in action with a long lens. **bottom right**—Bird photographers working with handheld cameras along the boardwalk at Wakodahatchee Wetlands, Florida.

blind, wait for my subject to become active, approach slowly, and grab the shot. Looking back, I think this helped me hone my skills as a bird behavior and action photographer.

Shorter focal length lenses give you the chance to shoot pictures that show the animal in its habitat and surroundings—

what I call a wildlife scenic. One of my favorite bird lenses is my wide-angle zoom lens. If I can get close enough and the scenery is wonderful, there is nothing better than a wide-angle bird scenic.

On the other hand, there are perks to using a lens longer than 400mm. A long

focal length gives you more working distance from the bird, which helps relax your subject. Wildlife and people have a fight-or-flight distance. If you get too close, the subject will disappear.

A photograph that shows a beautiful setting and includes an animal can be an award-winner. I use a 12–24mm Nikon zoom for my wide-angle work. Having the zoom capability allows me to crop to perfection. I frequently shoot wildlife scenics with my other lenses, too. When I find a beautiful setting, I try to figure out how to get a bird in the shot.

When you acquire more lenses, continue practicing. Shoot a flower pot

top left—One of the highlights in my life is traveling with my kids. This Laysan Albatross on Midway Island was very relaxed, as are all of the birds there. Alan used an 80-200mm lens and was too close to focus. **top right**— The backdrop in Homer, Alaska, is spectacular. I wanted to make scenic images with the Bald Eagles of the area. **bottom**—This Black Oystercatcher nested in a very scenic spot, and I shot it remotely with the camera on the ground while I was back in my car. The bird relaxed quickly with just my camera there.

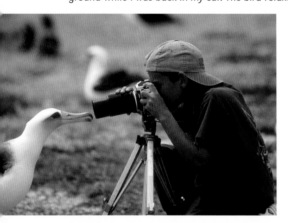

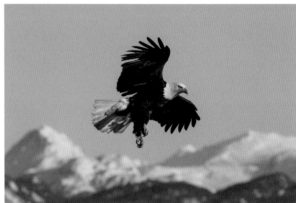

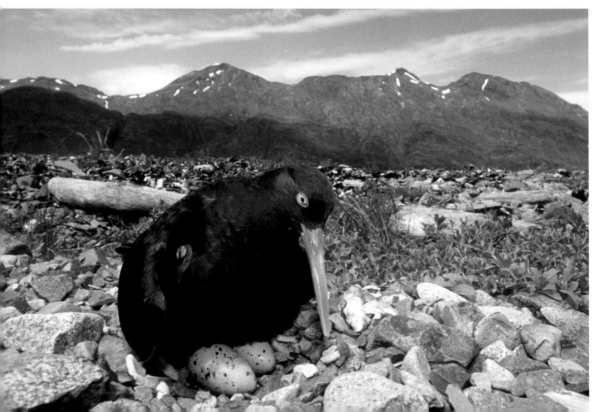

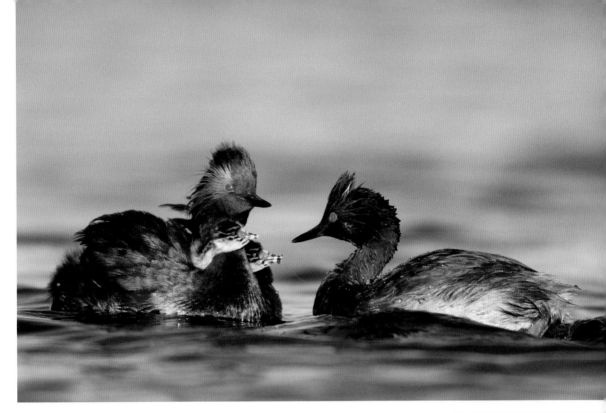

top—Eared Grebe family photographed with my 1.4X teleconverter on my 500mm lens, making it a 700mm. Can you see any loss in sharpness? **bottom left**—The Canon 2X teleconverter. Photo courtesy of Canon. **bottom right**—The Nikon 1.4X teleconverter (TC-14E III). Photo courtesy of Nikon.

with all your lenses and see how the image changes. Photograph your pet and other moving subjects. Put a bird feeder out, make photographs, and get to know your equipment. Take the time to practice. You will be rewarded.

Teleconverters

Many birds are small, and it seems photographers always want to get closer. A teleconverter is a lightweight and affordable way to achieve a higher magnification.

When shopping for a teleconverter, look for one made by the manufacturer of the lens and camera you have. The top camera companies offer remarkable sharpness at a price that is very affordable (about $500) compared to the super telephoto lenses. My $8000 500mm Nikon lens becomes an $8500 700mm lens with the 1.4X converter.

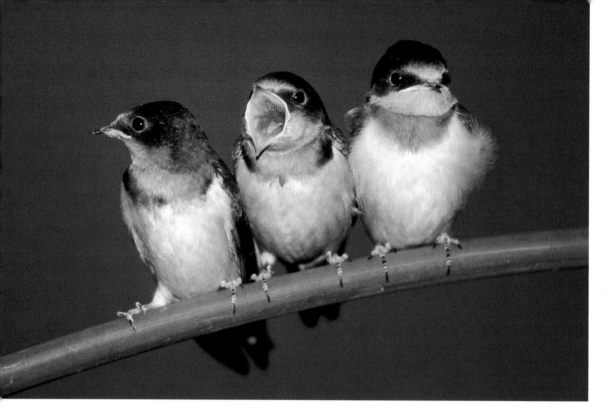

top—I used my PK-13 extension tube to get even closer to these Barn Swallow fledglings. **above**—Nikon PK-13 extension tube. Photo courtesy of Nikon.

You can see how this helps you get "closer" to your subject, with more magnification at an affordable price. The Nikon 600mm lens is $9500, but with a 1.4X teleconverter, it would become a $10,000 840mm lens.

The goal is to photograph with the prime lens and no teleconverter attached, for best quality, sharpness, and autofocus tracking.

I'd rather shoot without a teleconverter and crop in Lightroom to "get closer." This gives me more sharpness in my final images.

Extension Tubes

Extension tubes (also called extension rings) fit between your lens and camera body. These attachments, hollow rings without glass, are commonly used in macro photography. They allow your lens to focus closer than its normal minimum focusing distance so you can get nearer to your subject and make it appear larger in the frame. (The lens's minimum focusing distance is as close as you can get to your subject and still achieve focus.) Extension tubes come in handy when photographing small birds, especially hummers.

When using extension tubes, you lose the ability to focus at infinity. There will also

be a loss of light (the amount depends on the size of the tube). I use the Nikon PK13 ring, which results in the loss of a whole stop of light.

Extension tubes are affordable (about $50) and are compatible with the camera's TTL exposure system, but they don't autofocus to my standards. Nikon doesn't make an autofocus tube, so when using the extension tube, I use manual focus. It's not worth buying an off-brand tube that autofocuses, in my opinion.

Flash

Bird photography often requires adding your own light, and a good flash is a must. A lot can be done with one flash on-camera.

Get a flash with TTL capabilities and use it to add fill flash when the sun is your main light source. Using fill flash will lighten shadow areas and add a catchlight in the bird's eye. That sparkle in the subject's eye is important to give life and pop to your image. Adding a flash extender (Fresnel lens) to the front of your flash will narrow

top left—Late-morning photo, without fill, of Double-Crested Cormorant. **bottom left**—Shot made with fill flash (TTL -3). **right**—The late-morning image made with flash fill is passable, but I went back in the evening and got some nice light. When the subject is cooperative and you have the time, shoot in good light; it is usually the best option.

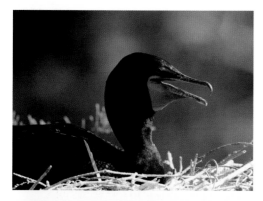

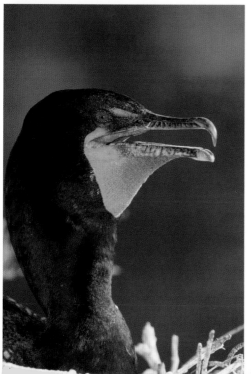

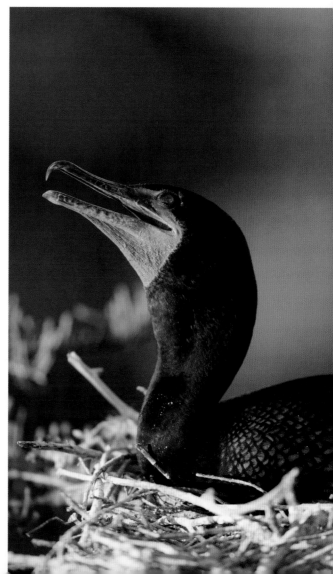

This photographer got low for a good perspective. When you want to stand up and shoot, look for a tripod that can be made tall enough to allow you to shoot without stooping over.

the beam of light and send it out farther, which is often where the bird is. Also, shooting rapid fire (i.e., in continuous mode) is extremely important in action and wildlife photography, and the flash extender helps speed up the recycle time of the flash. I use the Better Beamer by Visual Echoes. Be sure to get the model that is designed for your specific flash.

The downside to using on-camera flash is the potential for red eye. The solution is to get the flash off camera; you can place it on a bracket or have an assistant hold it. When you use this technique, you will need a cord that attaches your flash to the camera's hotshoe, as well as a bracket. The more you use your flash, the more you will see the value of using it.

Tripods, Mounts, and Heads

A sturdy tripod is a must to hold up heavy cameras and telephoto lenses. The tripod head is just as important for holding and moving the lens–camera combo. There are many different tripods and heads to choose

from. Get one that can stand tall enough for your height without having to extend the center post. When you raise the center post you are basically making your tripod a monopod, which is less stable. Stability is of utmost importance for quality imagery—particularly sharpness.

I actually remove the center post so I can splay the legs out and lie on the ground. I lose the ability to raise the center post though, which is okay with me. I like to carry my tripod over my shoulder with my big lens attached, so I'm ready to shoot as soon as I put it down. I add padding around the top of the legs to help my shoulder stay comfy. This padding also provides a barrier between the metal and my hands during cold-temperature shooting.

There are many styles and brands available, so check out some to see how they work. The basic differences are how the legs extend and what they are made of. Some you have to twist to loosen and tighten the legs. Others have latches that flip up to loosen and flip down to tighten.

Some tripods are made of lightweight, high-quality material like carbon fiber; others are more affordable and made of aluminum. It all comes down to your budget and what works best for your style of shooting.

For bird photography, the tripod head is just as important as the tripod legs. The head is designed to make your lens movement more fluid and stable. Many wildlife photographers, including bird photographers, love the Wimberley brand

Gimbal head. Others like a ballhead. The standard head that comes with a tripod is the three-control pan-and-tilt head. When buying your tripod, get it without a head and purchase the head separately. If you want to shoot more video, consider a video head. It will allow for easier, more fluid movements.

The Wimberley (Gimbal) is larger, more bulky, and heavier than a ballhead. Once it is set up with your heavy camera/lens, you can let go of it without worry that it will move or fall. It also pans and tilts smoothly. The ballheads are smaller, lightweight, and need to be tightened down when you let go. They are easy to maneuver but have only one control knob. A good ballhead costs about as much as the Wimberley. Whichever you choose, it's important to practice with it to become efficient.

I like the Arca-Swiss ballhead because it's what I'm used to. It is lightweight, compact, and has only one knob to control the movement of the camera/lens setup. I set the tightness adjustment on the ball so that if I let go of the camera, it will stay motionless in position, and when I move the camera it will move and track the bird. I spend a bit of time tightening and loosening it, and when I crank it down tight to photograph a non-moving bird, there can be some drift-down. If you do a lot of this kind of shooting, the more bulky Wimberley might be more useful.

Quick-release plates are the last piece of the puzzle. Two popular manufacturers are Kirk and Really Right Stuff. Using these plates can help to speed up the process of getting ready to shoot pictures. Both Gimbals and ballheads come with quick-release plates, which make attaching the lens to the tripod easy and fast. For the quick release to work on the tripod head, you will need male plates that attach to your lenses and cameras, so that is an extra expense.

Each lens and body has a unique custom plate; my 500mm lens has one, my D4 body has a different one. I leave the plate on the lenses and cameras. When I grab the camera, I just slide it onto the tripod head, tighten the screw knob, and I'm good to go.

Window Mounts

Window mounts are useful when you use your vehicle as a blind. There are many options on the market. For big glass, sturdiness is important. I use the Groofwin mount from Leonard Lee Rue. It can be used on the window, ground, and roof (hence the name). It is versatile, stable, and needs a ballhead mounted on it. There are many other window mounts, so do some research to find what will work best for you.

My first mount was a 4x4-inch piece of foam that was the length of my truck window. I would slice 2 inches into the foam and then place the slit over my car door's window, with the window rolled most of the

Here is Leonard Lee Rue's Groofwin mount on the ground.

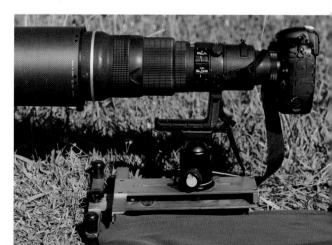

way down. The camera and lens would rest on top of the foam. It was an inexpensive option, but I couldn't let go of the camera, or it would fall off. Mounts that tighten onto the window itself don't seem sturdy enough for a big lens, so I prefer one that attaches to the door.

Many folks use a large beanbag that rests over the open window, much like my foam solution. When flying to locations, taking the empty beanbag and buying rice or beans on-site is a lightweight option. If I am planning to photograph from a vehicle, I bring my Groofwin mount and reduce weight some other way. Camera gear gets first billing. I will leave comfort items at home if I need to limit weight.

Camera Bags and Backpacks

Carrying your gear safely is a necessity. Also, with the long lenses required for photographing birds, your gear will be heavy. You'll need a bag that holds all your gear and is sturdy, protective, and easy to carry and maneuver. There are backpacks, shoulder bags, fanny packs, suitcases, and camera cases that can hold your gear. You can also use multiple bags. When considering your options, think about where and how you will be photographing. If you plan to travel the world, consider airline

luggage restrictions. If you plan to shoot close to home, a whole different thought process is in order.

There are a number of companies that make camera bags. I look for proven, professional, sturdy backpacks. Lowepro, Pelican, Tamrac, and Manfrotto are a few reputable manufacturers. Personally, I chose a backpack that is small enough to be used as an airplane carry-on but large enough to hold my big lens and all of my other critical camera gear. I also take a smaller bag that holds other supplies and my laptop. This setup is versatile enough for my use anywhere I am, protects my gear, and is easy to carry. Once I'm on location, I try to keep my 500mm lens ready to go and will carry it on my tripod, with a smaller backpack filled with the other things I need. To be honest, I am hard on my equipment, so durability is at the top of my list. My big lens is a tool, not something I keep in the bag for long. It is always ready to go to work, but it does travel in comfort!

The Lowepro Protrekker AW ("AW" stands for "all weather") is my larger bag, and I use the Lowepro Flipside 400AW when I'm in the field. Together, they hold all my gear. The larger Protrekker holds my 500mm lens, a body, and other gear (what I carry depends on my plans for each shoot). The two side pockets hold battery rechargers, extension tubes, extra flash cords, etc. I take them off and put them in my checked bags if I'm flying on a smaller plane, but I can carry it on most jets. The smaller Flipside 400 AW is checked in my

This Lowepro backpack is airplane carry-on size and holds most of my camera gear.

luggage. It's the backpack I wear for a shoot as I carry my 500mm lens over my shoulder. It holds an extra body, a wide-angle lens, a medium telephoto zoom, flash, and accessories like extra batteries, memory cards, flash cords, tele-extenders, extension tubes, a water bottle, etc.

I have also used the very sturdy Pelican cases for protection, and my Protrekker can fit in one. The problem with the Pelican cases is that they are very heavy, but they are waterproof, dustproof, and, well . . . *bomb* proof. I don't take my Pelican on the plane due to weight restrictions, but if I'm on a road trip, I take it for extra protection—especially if I plan to be around dust or water. There are a couple of other companies that make hard cases, and they all have the same basic setup with handles and wheels to help lug things around.

If you are a person who needs extra help carrying lots of gear, has a bad back, or is small in stature, then consider a rolling case.

Image Storage

Transferring your files from the camera's memory card to the computer is a must. I use and travel with a MacBook Pro and upload my files to external portable hard drives. Bigger is better when it comes to storage capacity. Get the most memory you can afford in the cards and hard drives. If you need a card reader, get the fastest speed you can and a good brand name. Memory cards offer a huge amount of storage space. Go as big as you feel comfortable with. Cameras that create big files require high-capacity cards. I use 64–256GB cards, so I can shoot lots of images before I have to upload them and reformat the card. It also gives me space to shoot some video if I choose.

When viewing images back home, a large monitor is magical and makes the images pop. There are many options here, though Mac users swear by Apple monitors. I do all of my editing on my laptop and view my work on a larger monitor. I even hook my laptop up to my HD-TV (via an HDMI cord) for viewing my work and sharing my photos with family and friends. Seeing an image that large can help me determine whether or not to make a big print.

I use 1 and 2TB external portable hard drives—and I travel with them (I'll admit, I am a bit old-school). When I am actively shooting and editing, I back up everything on a second hard drive every day. There are numerous storage options—from devices to Cloud storage. The best choice for you will depend on your preferences, comfort with the various options, and number of files you accumulate.

Software

There are numerous image-editing programs on the market. Adobe Photoshop and Adobe Lightroom are popular options, and I use both. Updates and new versions are now on the Cloud, for a monthly fee.

2. BASIC TECHNIQUES

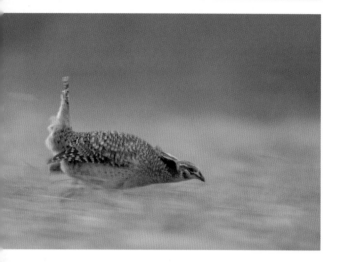

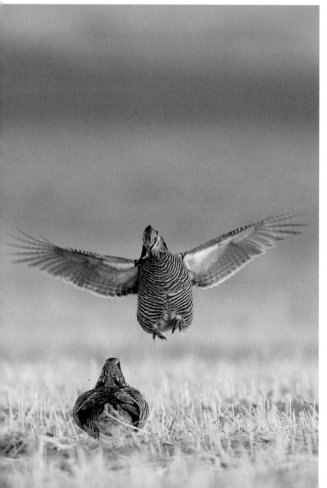

Exposure

Proper exposure is the backbone of a successful image. Photographers use three camera settings to ensure that just the right amount of light is used to form an image: the shutter speed, aperture, and ISO.

Shutter Speed. The shutter speed is a measure of the time that the shutter curtain is open and allows light to strike the image sensor. The basic shutter speeds range from 1 second to $1/2000$ second. When you move up or down one number (called "one stop"), the amount of light allowed to strike the sensor is either doubled or halved. For instance, when you change your shutter speed from 1 second to $1/2$ second, the amount of light that strikes the sensor will be cut in half. When you change your shutter speed from $1/2$ second to 1 second, twice as much light strikes the image sensor.

In addition to governing exposure, the shutter speed impacts image sharpness. When slow shutter speeds are used, a moving subject will appear blurred. (Note, too, that the slightest movement of the camera can also make for a blurry image.) Very fast shutter speeds freeze the motion of a subject to ensure it is sharp. Birds can move very fast, so a shutter speed of $1/1000$ second is usually the minimum requirement for a sharp image.

Aperture. The aperture is the adjustable opening in the lens that allows light in to strike the image sensor. Apertures are

top—To capture this image, I panned my camera at the same speed at which the Sharp-Tailed Grouse was running. My aim was to keep the bird sharp and allow the background to blur, so I shot at a shutter speed of $1/15$ second. **bottom**—In this image, the Greater Prairie-Chickens are fighting for rights to mate. A shutter speed of $1/1000$ second was needed to stop the action.

Here, the sharpness falls off from face to tail. Always make sure the eye is sharp. This image was shot at $1/2000$ second at f/5.6. The depth of field looks good, but it is shallow with such a small bird.

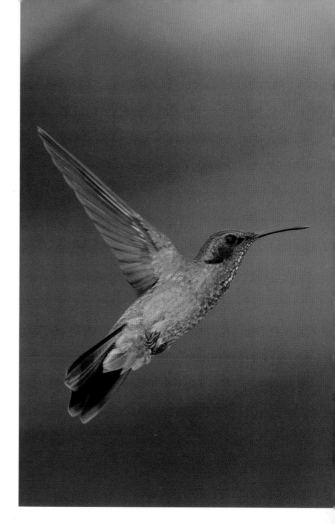

sometimes referred to as f-stops. The most common settings are f/2.8, f/4, f/5.6, f/8, f/11, f/16, and f/22. The larger numbers represent smaller-diameter openings, and these smaller apertures allow less light into the camera to make an exposure. Making a one-stop shift in aperture will halve or double the amount of light that strikes the sensor. For example, if your aperture is f/8 and you move to f/11, you will reduce the light by half. Moving from f/11 to f/8 will double the amount of light that reaches the sensor.

The f-stop also controls the amount of the scene, from front to back, that will appear in focus. A wide aperture like f/2.8 allows for a very shallow focus depth, while a narrow aperture like f/22 allows for much more of the scene to appear in sharp focus. This phenomenon is referred to as depth of field, and it is an important tool in creating effective images.

Depth of field is also affected by the focal length of the lens. Telephoto lenses compress the image and make a shallower (narrow) depth of field with less of the image in focus. A wide angle lens will show a wider view and give more depth of field.

ISO. The ISO (an acronym that stands for International Standards Organization) is a setting that determines the light sensitivity of the image sensor. Standard ISO settings are 50, 100, 200, 400, 800, 1600, and

Ensuring Sharp Images

Many bird photographers use long lenses to magnify the apparent size of their subject. Unfortunately, with long telephoto lenses, blur related to subject movement is exaggerated. For this reason, working with a tripod—rather than handholding your camera—is a must for sharp photographs.

If you're tempted to work with a handheld camera, keep in mind that the rule of thumb for preventing blur from camera movement is that the shutter speed must be roughly equivalent to the inverse of the focal length of the lens. This means that if you were handholding a 50mm (normal) lens, you'd need to use a shutter speed of $1/60$ or faster to ensure a sharp image. With a 200mm lens, you'd need to shoot at $1/250$ or faster, and so on.

3200. If you need more light for a proper exposure, adjust your ISO to a higher numerical value. The side effect of increasing the ISO is more noise (dots and colors in the image; a digital equivalent to film grain). However, today's digital cameras, especially the top-of-the-line models, allow shooting at ISOs of 4000 or higher with little noise. My Nikon D4 images look good even at ISO 4000, but I try to keep my ISO setting under 2000.

Let's look at a scenario that will help you to better understand how changing the ISO can help you meet your image objectives.

Imagine that you want to shoot a front-lighted subject using a $1/2000$ second shutter speed and an aperture of f/4. The sun is setting, so you will need more light for a proper exposure. The maximum aperture on your lens is f/4, so you cannot choose a wider aperture to let more light into the camera. You cannot reduce your shutter speed because you want to ensure that your fast-moving subject will be sharp. Your only other choice is to set the ISO to the next higher number. (Technically, using flash is an option, too—but we'll save that discussion for later.)

Fractional Exposure Settings

Today's digital cameras allow photographers to make fine exposure adjustments. Depending on your camera, you may be able to increase or decrease any exposure setting by $1/2$ or $1/3$ stop. Consult your camera's manual for details.

In this side-view image, the entire front of the Gadwall is in the same plane of focus.

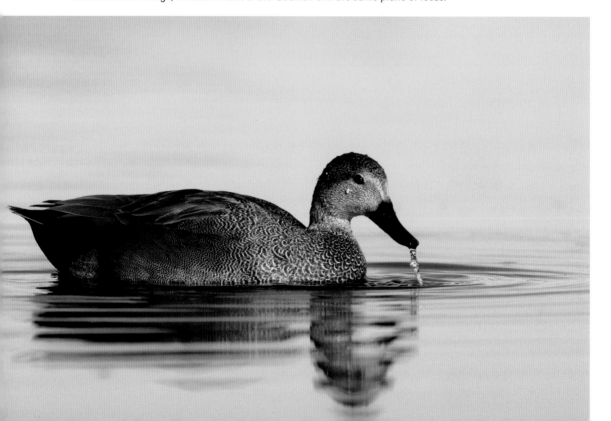

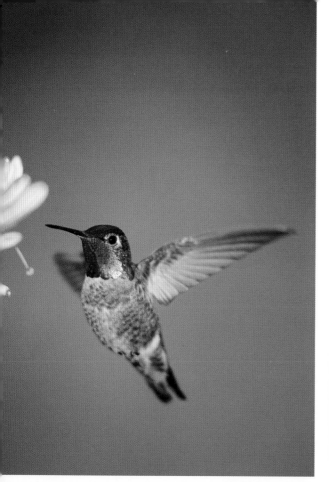

top left—This Anna's Hummingbird was photographed at ISO 2000. **top right**—The Anna's Hummingbird at the feeder was photographed at ISO 400. **bottom**—This Black-Chinned Hummingbird was photographed at ISO 4000. Compare the noise and sharpness in each image to better understand the impact that the ISO setting has on images.

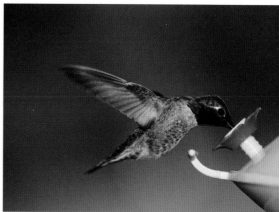

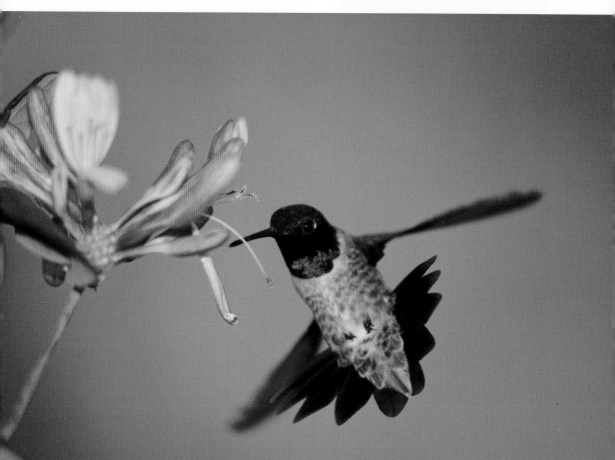

Here is the histogram for an image of a woodpecker. The graph shows that the majority of image tones fall in the midtone area. It is a good exposure— the data is not bunched up at the far left or far right edge of the graph.

In the histogram for this Great Egret image, the tonal data does not extend past the far-right edge of the graph. This means there will be visible detail in the white tones of the bird. There is a lot of data at the left edge of the graph. This is because the background is darker than mid-tones. Notice that the top of the background contains black tones. In the graph, these tones are clipped. I'm okay with that because I wanted detail in the white bird.

The histogram for the image of a Sage Grouse shows a major peak in the middle. This is because most of the tones in the image fall somewhere near the center of the tonal spectrum. The data on the left side and right side are clipped. This tells us there is no detail in the darkest and lightest tones in the image.

Histograms

A histogram provides a graphic representation of the tones in your image. It is an indispensable tool for evaluating exposures. I set my camera so that the histogram automatically shows on the LCD when I take a picture.

In the histogram, dark tones appear on the left, midtones are shown in the center, and highlights are shown on the right.

Most images are predominantly comprised of midtones. When we look at the histogram for an average image, therefore, we will see that most of the data falls in the center area of the graph. If the data extends past the left side, there will be no detail in the blacks (i.e., the shadows will be underexposed). If the data extends past the right side, the brightest highlights will not show detail (i.e., the whitest tones will be overexposed). Of course, these are rules of thumb. Perhaps vast dark areas are your aesthetic preference. Sometimes it is okay to lose detail in the shadows or highlights, so long as your subject has detail.

If you are capturing a scene that deviates from the norm—e.g., one that is predominantly light or dark—the histogram will look very different. For example, in the histogram for an image of a mid-toned bird in the snow, most of the tonal values will be graphed toward the right of the histogram, but the tones of the bird would be represented more toward the center. For an image of a White Egret in a snow squall, the histogram data would fall to the right. In this case, though, you will want to try to keep the data from extending off the right edge to retain detail in the whites. This is called shooting for the highlights. But again, this is a generalization. Proper exposure will ultimately depend on your vision and the subject/scene you are photographing.

Understanding and controlling exposure is key to making good images. No amount of Photoshop work will bring back missing detail in under- or overexposed images. The key is to get it right in the camera.

In the field, I check the histogram and adjust my exposure as needed. Whenever the bird moves, the elements in the scene change, or the light changes, I check my histogram and make any necessary changes to my exposure settings.

Bracketing

The term "bracketing" refers to the practice of making a series of exposures using slightly different settings to improve the odds of getting a "correct" image. With film, we had to bracket all of the time. We'd take an exposure reading, fire away, and then shoot at one stop over and under, just in case. Now that we can check our exposures by analyzing a histogram, there is no real need for exposure bracketing. However, I still bracket my shutter speeds and even my f-stops for a different depth of field.

When I pan and pan blur an image (more on this later), I often bracket my shutter speed to see which one works best as the bird moves. You can fine tune your settings, check the results in real time on the back of your camera, and then shoot away.

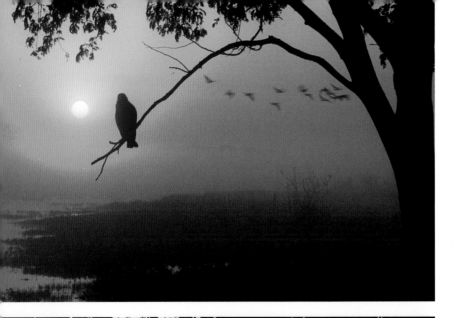

top—This Black-Collared Hawk was sitting on the branch during sunrise, so I decided to bracket the f-stop. This image has a larger f/stop (narrower aperture) and more depth of field. To compensate for the loss of light with a small aperture, I used a slower shutter speed and was not able to freeze the motion of the flying ducks. They appear blurred. **center**—This image was shot at f/8, and there is less depth of field. The sun is less sharp, as are the weeds in the foreground as compared to the image made at f/16. Both images work for me. I prefer the added bonus of the ducks flying by; unfortunately, though, the hawk turned its head. Also notice how the color changed in the sky. The color changes quickly at sunset and sunrise, especially near the equator. **bottom**—I zoomed to 500mm for a larger sun and bird in the image, but decided to keep the sun off to the side with the Black-Collared Hawk looking at it.

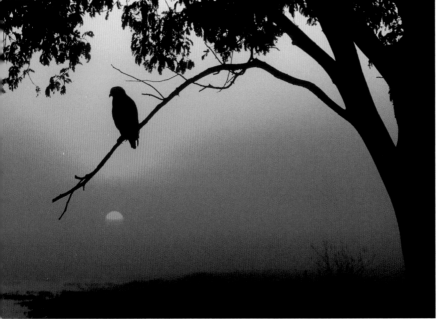

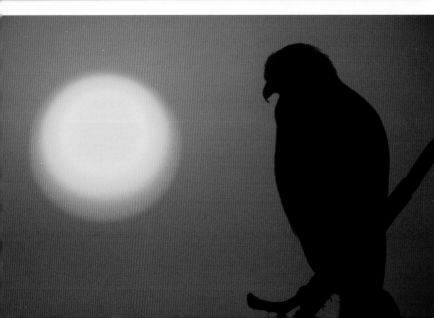

White Balance

Every light source that we encounter has a distinctive color, which is described in degrees Kelvin. Light with a high Kelvin temperature rating is bluish, and light with a low Kelvin temperature rating is yellowish. Our eyes compensate for these color shifts so that the colors appear neutral. Digital cameras "see" things as they really are. Therefore, we rely on the camera's white balance feature to neutralize color casts.

Light from the sun at around noon is white. In a shadowed area, the light from the sun is bluish because the sky color is reflected in the shadows. Light from an incandescent bulb has a yellowish cast, as does the light from the sun at sunrise or sunset. To achieve neutral color results, we can dial in a white balance preset in-camera or we can enter the color temperature of the light source we are working in, if known. Presets come in handy when working in known conditions, when there is light of just one type present. For example, selecting the cloudy white balance preset yields pretty good results when you are photographing your subject on a cloudy day.

It is also possible to make color temperature adjustments in postproduction.

Focus Modes

Continuous Focus. Today's DSLRs offer a feature that allows you to focus-track a moving subject. This is an invaluable tool for action photography. It's great to know that you can use your camera to shoot a sequence of in-focus images of a moving

top—Here is an image of a Reddish Egret. The color temperature here is 5569 Kelvin. **center**—Here, the color temperature is 4900 Kelvin. **bottom**—Here, the temperature is 4037 Kelvin. These three images show three different temperatures using the white balance slider in Lightroom. Don't worry if you forgot to set your camera's white balance. It is an easy adjustment later in Lightroom. I move the Color Temperature slider back and forth until the image color looks right. Which one is correct?

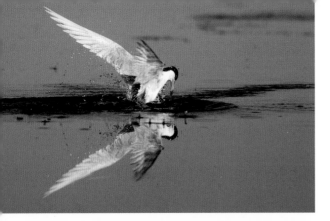

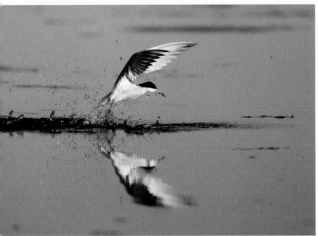

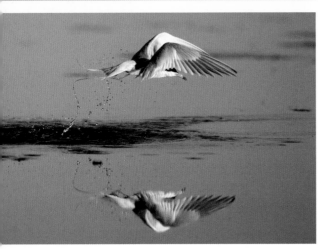

Here is a trio of images of a Forster's Tern diving for fish. I made the images using the motor drive or continuous autofocus mode. My Nikon D5 will fire at a rate of 12 frames per second at full resolution, which is what I use.

subject, but it is still important to wait for compelling action to press the shutter.

In continuous focus mode (Nikon calls it AF-C mode, Canon calls it AI-Servo), the camera actually tracks and keeps up with the movement of the subject. It helps to pan the camera, keeping the focus sensor on the bird's eye as it flies past. One of the most challenging photos to capture with manual focus is a bird flying right toward you. With autofocus (AF) settings today, it is an easy shot.

Optimizing Your Focus. Digital cameras allow you to choose from various focus modes. In my Nikon's Dynamic AF Area Mode, I can choose the number of focus sensors the camera will use. I choose them all (51). This helps the camera track even when it is difficult to keep the focus sensor on the bird's eye. I still set the original focus point manually, and when the bird moves away from that sensor, all the sensors are supposed to act as backups to find that original point. It is a good idea to practice tracking moving subjects with your camera to sharpen your focus tracking skills.

Focus is easy to attain when the subject is presented in a simple setting (e.g., a bird against a solid blue sky). Also, when the bird is moving predictably, like right toward you, or from left to right, the focus is amazingly accurate. You can hold down the shutter button and fire away, and most of the images will be in focus. When the bird is moving unpredictably, you have to refocus often. I set the original focus sensor on the bird's eye and try to keep it there as the

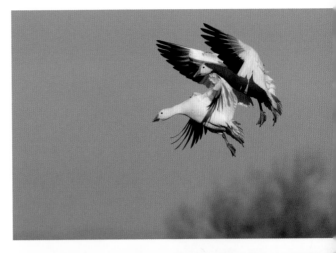

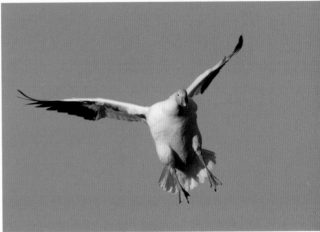

top—Photographing Snow Geese flying past you is more challenging than making the image with the birds are flying toward you. You have to pan with the birds and keep the autofocus sensor on an eyeball. **bottom**—A Snow Goose in flight. With autofocus, it is easy to capture an image of a bird coming straight toward you, as not much panning of the lens is needed. Once you have the middle sensor on the bird, the camera tracks well.

bird moves. If the bird is stationary and I'm shooting a portrait, I will move the focus point to the bird's eye. After that, if I am anticipating a yawn, I will move the focus point up to where the eye or mouth will be during a yawn. If there is no focus point where the eye is, I will focus on the eye, press and hold the focus lock button on the back of the camera or on the long lens, and recompose before I shoot.

When I am anticipating behavior in a certain direction, like a bird flying off of a branch, I place the focus sensor where I predict the bird will be. I also tweak the focus manually as the bird moves its head around and back and forth. Birds are rarely still for long, so refocusing is important.

Practice Makes Perfect

Take your gear out when you are at home and photograph anything—the kids, pets, or couches—just get to know your gear. A week or so before a shoot, plug in all of the batteries and make sure your memory cards are emptied and formatted. Then go outside with your gear and shoot. Practice putting it on the tripod, panning, focusing, and setting the exposure. This will save you precious time when you are in the heat of the moment, with bird action all around you.

Read and reread your manual. Find the settings that are most useful to you and customize your camera settings. Know what they do and why they are best for your photography. I will often take my manual on the airplane with me and reread some sections. Today's top-of-the-line cameras are sophisticated computers and have many features that can benefit us bird photographers.

In addition to practicing with your camera gear, you should upload images

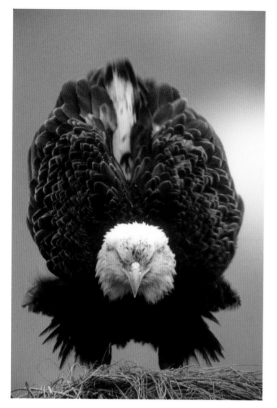

left—Bald Eagle stretching. Practicing allows me to keep my reflexes and skills sharp; therefore, I miss far fewer shots. **above**—Here is the photo on the cover of my *Baby Birds* book. I like the cute factor, the diagonal perch, and color, in addition to the necessary basics of exposure and focus. You will also notice that I used fill flash to balance the dappled light.

to your computer and practice optimizing them. Be sure to back up your files on a hard drive or on the Cloud.

When you are looking at photos in books and magazines, study why you like them and try to figure out how they were taken. Enjoy the beauty of your favorite images, figure out what it is that makes them great, and emulate the parts of the image you enjoy. This will help you create your own style and can inspire new ideas.

I like to clean my gear when I get back from a shoot and during the outing when it needs it. I make sure the lens and external parts are free of dust and dirt. I even keep the tripod clean so the legs slide easily and function smoothly.

Not every photographer wants to be a full-time professional; most shooters get out as often as possible. There will be times when life comes first, and the camera gear will sit around collecting dust.

Natural Light

For bird photographers, the sun is usually our main light source. Most nature and wildlife photographs are made early or late in the day, when the sun is low on the horizon. At this time of day, we get nice, warm light on our subjects and the sun throws long shadows.

The position of the sun relative to the subject has a big impact on our images.

When the sun is behind the photographer and falls onto the front of the subject, we have front light. Pointing your shadow at the subject is the rule of thumb for front-lighting, and it is usually your goal when photographing birds.

When the sun is behind the subject and the photographer is on the subject's shadowed side, back-lighting exists. Back-

3. LIGHTING

lighting can create some of the most dramatic light for exciting and fresh images. In this scenario, subjects may appear in silhouette. The lower the light is on the horizon, the better the results tend to be.

When the light is off to the side of the subject, we have side-lighting. Side light can create a unique look in your images. However, it is important to wait for the bird to turn its head to ensure the light strikes the eye and creates a catchlight.

This image of a front-lighted Rosette Spoonbill was made with the sun at my back and my shadow pointed at the bird. All of the front side of the bird is illuminated, and there is a catchlight in its eye.

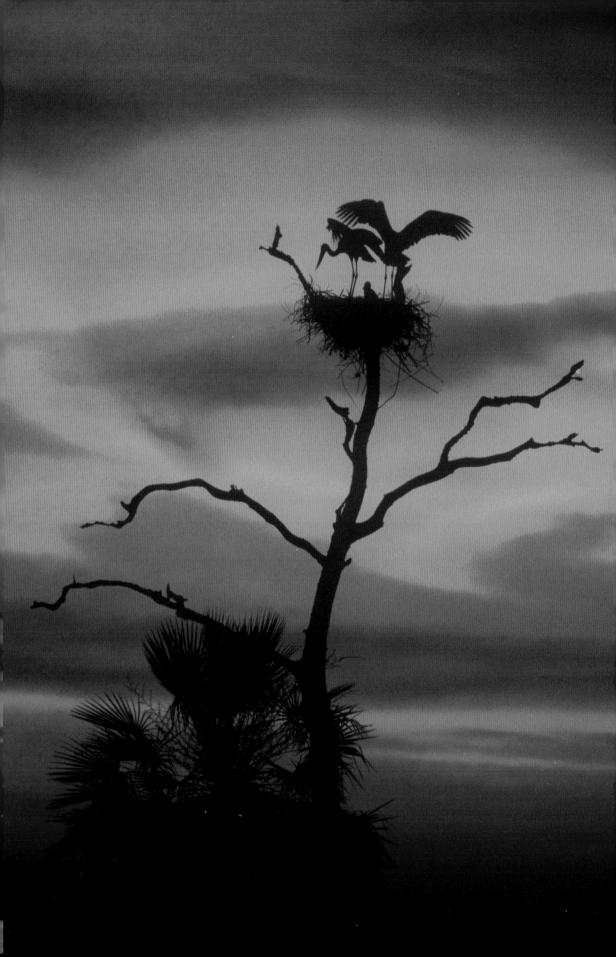

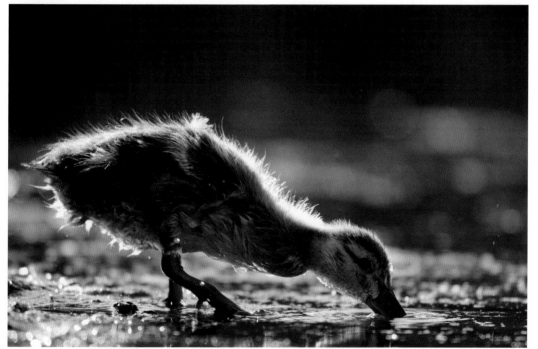

facing page—The light at sunset or sunrise can make for a dramatic image. Here, the early-morning sun came from behind the Jabiru Storks in their nest, so the subjects are silhouetted. **top left**—This image of a Black-Bellied Whistling-Duck was made with side lighting. The head is in shadow, so there is no catchlight. I usually prefer side light with a catchlight. If you are shooting with flash, you can add one. **top right**—Overcast light helps the shadows disappear and creates a soft look. In an overcast setting, there will be no catchlight, though. You can add a catchlight with flash, but sometimes flash isn't warranted in overcast conditions. Whooper Swan. **bottom**—This back-lighted baby duck glows with rim light. The feathers just pop! I like to expose for the shadowed side and shoot one stop darker when I'm not using a flash. This is a case in which bracketing helped. I liked this version best. There is roughly 1.5 stops of underexposure on the shadowed side, which leaves just enough detail in the lighted feathers. The proper exposure also depends on the color of the bird's feathers. In this case, they were white, so less light was best.

Artificial Light

A lot can be done with flash or artificial light. I like to use just enough flash to fill in shadows and make for more even lighting throughout, but I don't want the use of flash to be obvious in the image. As mentioned earlier, using flash can also create a catchlight in the bird's eye when one does not naturally occur. When adding flash, work carefully. Attaining proper lighting takes a bit more effort in the field, but with good light you'll need to do less image-enhancement work in postproduction—and, in my opinion, adding light when needed gives better results overall. Another perk to using flash is that I can shoot all day if I choose—with flash, I can even soften the harsh shadows that result at midday.

The key is to set the flash to TTL and then adjust it to minus $1\frac{2}{3}$ ($-1\frac{2}{3}$) and see if you get the results you are looking for. Experiment with your camera and flash TTL settings. It seems there is variation with different makes and models. I recommend doing some test shots at home with your family pet and bracketing your flash to determine what TTL setting works best. I use -3 a lot; I know some photographers who set their flash to -2 TTL and others who use -1 TTL. Find out what is best with your setup and what look you like best.

My rule of thumb is, "I don't want to notice the flash, but I want to see better lighting." You can see this is somewhat subjective.

Adding a flash extender or Fresnel lens in front of the flash will send the beam of light out up to three times farther. This is quite useful when photographing wildlife subjects that are beyond the normal reach of the flash. The Better Beamer flash extender is very popular, inexpensive, lightweight, and easy to use, carry, and store. Walt Anderson has received widespread recognition for his invention of the Flash X-tender, which is distributed worldwide. (It is also marketed under the name Better Beamer.)

Catchlights

In bird photography, having a catchlight—a reflection of the light source in the bird's eye—gives the bird life and really makes the image pop.

Wait for the bird to turn its head so the light source (sun or flash) reflects in the eye, and then focus on that. A sharply focused eye is critical for a good image. There are times when blurring the bird on purpose is good fun and artistic (more on this later), but mostly get it sharp!

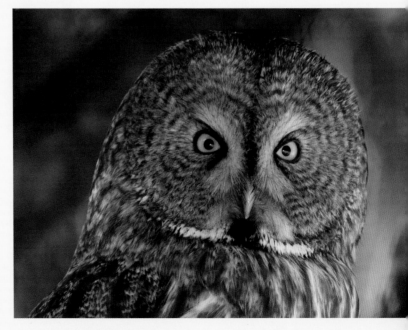

A word of warning: if the sun shines through your Fresnel lens, it will melt holes in your flash. Keep an eye on where the sun is in relation to the Fresnel. If need be, remove it to keep the sun from shining through it.

Flash batteries run down quickly, so I use an external battery pack from Quantum. The battery pack gives me the opportunity to shoot most of a day without having to change batteries in the flash. The Quantum 1+ battery recycles the flash quicker than AA

left—Here is the whole setup with the cords, battery pack, flash on bracket, and 500mm lens on the Bogen tripod.
right—One of my favorite uses of flash is to put my background in the sun and my subject in the shade and use TTL flash to create a more balanced exposure. It allows us to shoot at midday and get nice-looking images. This Northern Flicker nest was pretty active and in the shade all day. After my morning shoot elsewhere, I came back at about 1:00PM and nailed the shot.

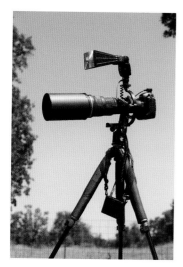

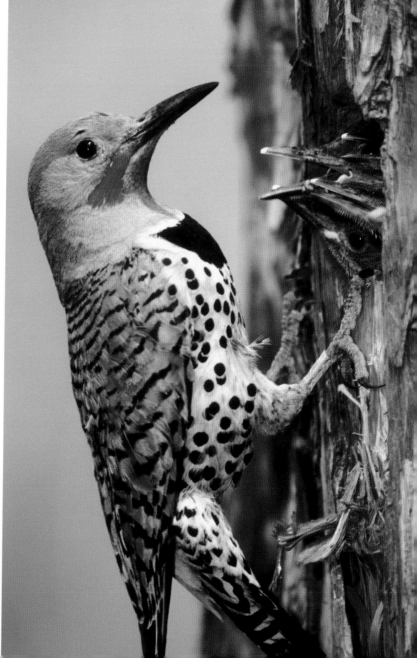

batteries, so there is less wait time between captures. In fact, I can shoot a burst of frames, and all of them will be lighted. When using a Fresnel lens, the amount of power needed to light the subject is less, so the batteries will last longer and the flash will recycle faster.

When you photograph owls or other birds with large pupils and use flash, you may see a yellow or red shine or glow in the eyes. The cause of the eye shine is light reflecting off the retina in the back of the eye. The quick burst of light from a flash doesn't give the pupil time to shrink down. Some cameras offer a red-eye reduction feature. When active, bursts of blinking light are emitted before the capture. This causes the pupil to shrink enough that the light can't reflect off the retina and come back to the camera. The best way to avoid red eye is to take the flash off camera. You can use a bracket to hold the flash to the side of the camera, or you can enlist the help of an assistant to hold the flash for you. Another option is to photograph the subject when it isn't looking directly at the camera.

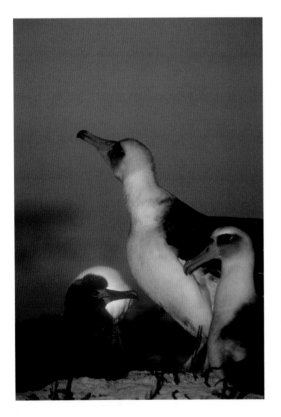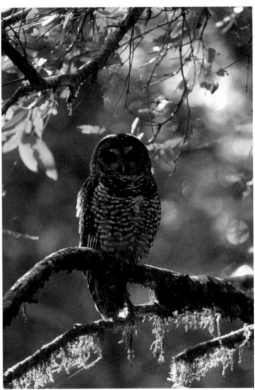

left—When you are shooting at sunrise or sunset and your bird is backlit, your subject may be a silhouette. If you add fill flash (i.e., a bit of flash to even out the exposure and lighten dark shadows), you can bring out the color of the bird. Bracket your shots using varying flash output settings to ensure you have an acceptable image. This image of Laysan Albatrosses was made with a TTL $-2/3$ flash setting. right—This Northern Spotted Owl was back-lighted by the sun. I added just enough fill flash to give some color, detail, and add a catchlight. I had my assistant (a biologist friend who works with these owls) hold the flash off to the side of my camera.

 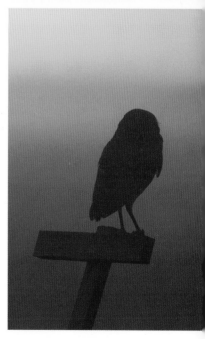

top—This Burrowing Owl was photographed with the flash on the camera's hot shoe at –0.66. You can see the red-eye effect. **bottom**—In the left image, the owl was photographed with the flash off camera at TTL –1.5. The center image was made with the flash off camera at TTL –3. The right-hand image was made without flash. Which image do you like best? Isn't it nice to have them all and decide later?

4. COMPOSITION

hat do you want to put in your image, and where will it go? Composition is the art of deciding that. There are some basics that apply artistically to all photography. There are some rules for bird images, but mostly it is your artistry and how you choose to compose a shot that's most important.

Image Format

Be sure to shoot vertical and horizontal compositions and know when one is better than the other. If the bird is tall, then a vertical composition might be best. Cover images for magazines and books are usually vertical, too. When photographing groups of birds, a horizontal composition may be in order. Whether you choose a horizontal presentation or a vertical one, it is generally a good idea to leave more space around your subject at the top of the image and less at the bottom.

Depth of Field, Revisited

Depth of field is an important part of the image-design process. Use it to communicate your intended message to your viewers. Understanding that $1/3$ of the depth of field will be in front of your focus point and $2/3$ will be beyond the focus point will help you previsualize and plan for effective results.

If you choose a wide aperture and shoot a front view of a bird's head looking straight at the camera, only a slice of the head will be in focus, so make it the eyes. If the eyes are in focus, the tip of the beak and the back of the head will be out of focus.

If you are able to use a narrow aperture, you may benefit more from focusing just in front of the eye because you will get more in focus beyond the focus point. With film, I used to shoot wide open (smallest number f-stop) and work to get the eye sharp. Today, I am able to shoot at higher

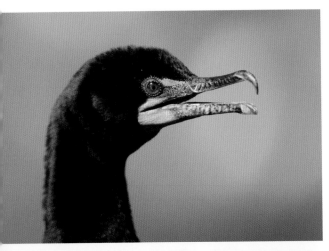

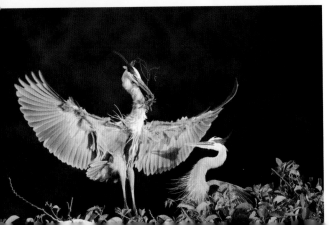

top—Double-Crested Cormorant close up. You can see the shallow depth of field produced by a long lens. The closer you are, the more dramatic the shallowness (i.e., there is less depth of field). In macro photography, the depth of field is very shallow. **bottom**—Here is a shot made with the same 500mm lens. The subject is farther away, so there is a greater depth of field. Notice the whole body of both Great Blue Herons is sharp.

top—With a shorter lens, depth of field increases. You can see the difference here. All of the Sandhill Crane chick's beak and head are in focus. This was taken with my 80–200mm lens at 200mm. **bottom**—The juxtaposition of the Sandhill Crane chick and its mom is sweet. The depth of field is fine with the chick turned sideways to the camera plane.

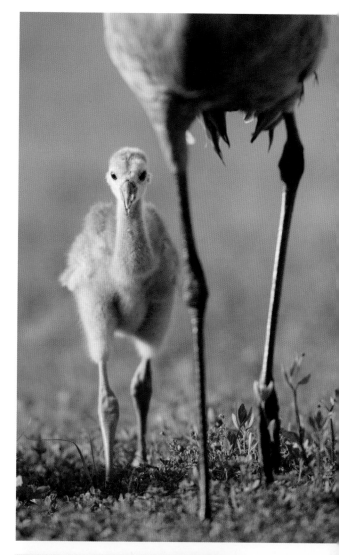

ISOs, so I can use smaller apertures like f/8 or f/11 for a wider depth of field. If I have time and I am shooting for depth of field, I will even bracket the shots' focus points and determine later which image has the amount of focus I want.

The Rule of Thirds

The rule of thirds is a recipe for positioning your subject and other image elements to create a visually compelling photograph. To use this tool, imagine that you will draw lines to divide the image into thirds, both horizontally and vertically. The rule states that positioning a subject on one of these thirds lines makes for good, dynamic placement. The four points where the vertical and horizontal lines intersect are called the power points of the image—and these are considered the best-possible place to position your subject (say, the eye of the bird in a bird portrait).

You will notice there are no lines in the center of the image. When composing the image, you should think about getting the subject out of the middle of the frame and off to one side or the other. The "bull's-eye" mentality is one of the amateur photographer and, in many cases, a centered subject can make for a static image.

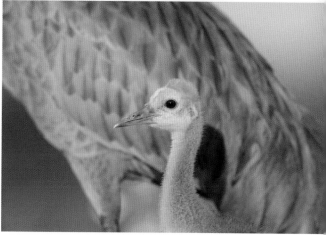

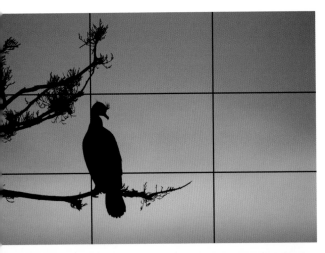

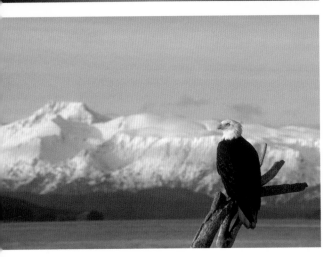

top—Here is an image of a Double-Crested Cormorant silhouette with the rule of thirds grid lines. The four areas where these lines intersect are known as power points. **center**—In this image of Snow Geese at sunset, the sun is pretty close to centered, but the horizon is in the bottom third of the frame. It is good to position the horizon along one of the thirds lines, not across the center of your image. **bottom**—The mountains at sunrise were beautiful in their own right, but adding the eagle off to the side at one of the rule of third power points really elevated this shot. A true bird scenic.

Of course, there are times when dead-center subject placement works. On occasion, when you are trying to get a certain part of the bird in the frame, you just gotta do what you gotta do.

Negative Space

Negative space, an area void of interest or much less visually significant than the subject, is often very helpful in the composition. Negative space makes the bird stand out in the image, sometimes in a magnificent way. Negative space can become an image unto itself: imagine a silhouette of a bird in a tree with beautiful branches. The negative space would be the sky, the area where no tree or bird is.

Elements of a Strong Image

Strong color and a simple composition can make for an artistic shot. Look at the foreground and background and incorporate them to infuse the color beauty. Be sure there are no extraneous elements in the image. Keep things clean and simple.

Adding action is my favorite way to improve a wildlife image. Staying patient

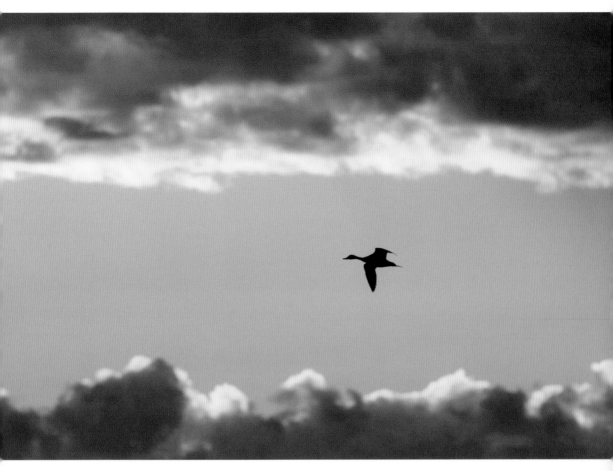

Northern Pintail in flight through the negative space of an interesting window of clouds.

and knowing what to expect from the bird helps me to anticipate and capture important actions and behaviors.

Now that you know what makes a good photo, it is time to practice these techniques. I like the advice of *National Geographic* photographer, Joel Sartore, who says, "Don't shoot junk, figuring you can delete it. This wastes time. Is the picture interesting? Is it composed cleanly? Would you nudge the person next to you to take a look? A good picture is a good picture, no matter the medium."[1]

Yeah, I like to make people think.

1. http://www.digitalcameraworld.com/2012/02/08/famous-photographers-225-tips-to-inspire-you/6/.

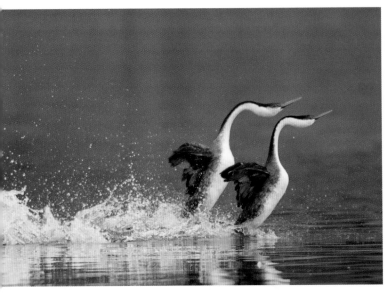

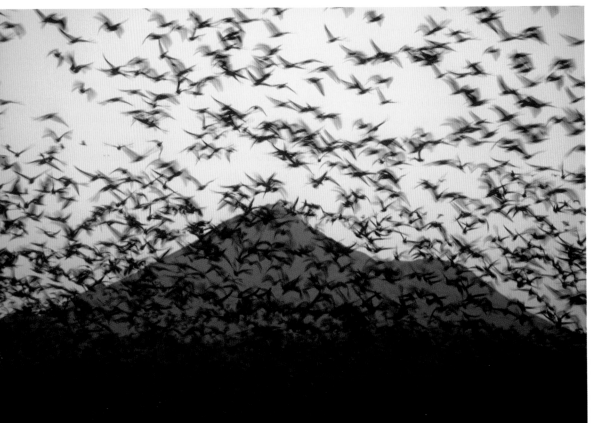

top left—Western Grebes rushing. This is the Grebes' mating dance and a unique behavior. Such displays can keep viewers looking, as they try to figure out what is going on in an image. **top right**—This Bald Eagle shot has been used many times and is in a 2015 calendar for Yosemite National Park. Notice how the composition keeps your eye looking at the birds and circling back up to their beaks. The calendar company actually cropped off the top and made it a horizontal. Notice the composition has more space above the birds and less below. This is generally a good idea for compositions. **bottom**—Sometimes chaos *is* the shot. I am always trying to incorporate nice backgrounds and compose bird scenics. In this case, Mt. Shasta looms in the background of a chaotic flock of Snow Geese. Remember, breaking the rules sometimes makes for the best shots.

Patience

While birding often involves seeing as many birds as you can in a short period of time, bird photography requires a real investment of your time. For me, bird photography is a different form of birding and a high level of bird watching. I recommend doing some birding and hanging out with birders once in a while; you can learn a lot. But if you want to capture birds with your camera, it is easy to get frustrated on a birding trip. These groups move more quickly than do photographers, who need to be patient and wait for the great shots. Still, bird watching will lead to better photos, as the more you know about birds and bird behavior, the better you will be at bird photography. When I am with a group of birders, I often photograph the people using binoculars, pointing, all surrounded by nature, and that becomes a photo that will help tell a story. I try not to get frustrated if it is tough to capture the birds. I simply photograph the other stuff that helps to tell a story.

I use a tripod and plan on waiting and being with a bird for a while. The tripod allows me to relax and hold a composition without effort. I can let go of the camera if I need to squirm, and it will stay on target. I spend as much time as possible with my eye to the viewfinder. I concentrate on relaxing my non-photo eye, too. When I'm looking through the viewfinder with my right eye, I keep my left eye open or close it gently. I get the portrait of a bird at this point and prepare for the action shot. If the bird won't be moving much (e.g, if it is in a nest), I

5. BEYOND THE BASICS

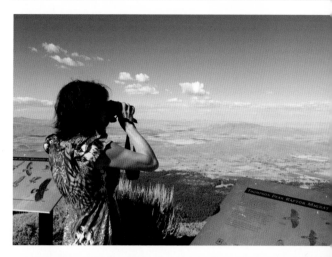

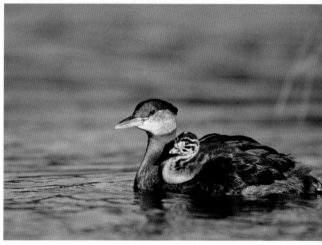

top—You can learn a lot from birders. On birding trips, I tend to photograph the people because trying to make a bird photo on a trip that is in constant motion is frustrating. **bottom**—Knowing that Grebes carry their babies on their backs allows me to prepare and previsualize my shot. Red-Necked Grebe.

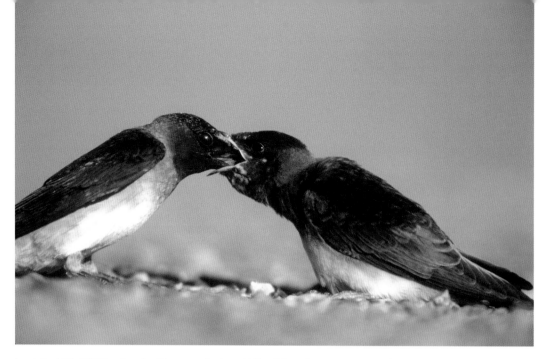

I watched this Cliff Swallow feed its young in the middle of the refuge tour route. What a great shot that would have made. After the adult left, I worked my way into position, prone on the gravel road, and waited while I photographed the chick. I the adult would return and feed its young again before a car came by. You can see how having the lens on the ground made the road almost disappear. The wait was well worth my time.

might use a cable release and sit back in a chair, ready to trip the shutter without looking in the viewfinder—especially if the nest is far enough away to allow for more depth of field. In this case, a little movement from the bird won't put the eye out of focus.

When in a prone position and trying to capture a low-angle view of ground-dwelling birds, staying comfortable is not easy. Anything you can do to add comfort is valuable. I use a pad to lie on—actually, it's a stadium chair with a back that unfolds into a mat or clips into a chair formation.

Prepare and Previsualize

Once you have all the basics down and know your gear well, it is time to make great bird photos. Being prepared and previsualizing

your shot helps when photographing wildlife, especially birds. Learning all you can about your subject will improve the resulting photos. There are many ways to research, including books, apps, the Internet, and being in the field, but I like to learn through the lens. While shooting, I observe my subject and surroundings. This gives the opportunity to learn important behaviors—and these behaviors are often repeated. A bird, for instance, will often defecate before it takes flight. Knowing these details will put you in ready mode to capture the shot of a bird taking flight just after it defecates; if you missed a yawn shot, be ready because the bird might repeat it.

Anticipating behaviors is crucial for capturing action. When birds bathe they

dip, wing flap, and twist in the water, and drops fly everywhere. They preen, shake, and get all wet, making great opportunities to capture action photos. When birds are finished bathing, they stretch up and wing flap, spraying water all over again. This helps them dry and gives us the opportunity to capture a great action photo. When you're expecting this action, be sure there is enough room around the bird so the wings and water will be in the composition. The birds will stretch up slightly too, so be sure there is enough room. Shoot loose.

After the wing flap, birds often begin a preening session. This is another great opportunity for behavior and action photos. If you are close and in position to make tight portraits and a wing flap happens, you may get images in which parts of the wings are cut off. Some cropped photos can be great (I have lots of these!), so shoot the action. But if you are shooting loose and the bird wing flaps, you will have ample room to get all of the bird parts in the composition. It is also much easier to focus when you are not so close.

Portraits and Headshots

When creating a bird portrait, get close enough to fill the frame, but leave room around the bird. Dawn Hewitt, managing editor of *Bird Watcher's Digest*, looks for photos with space for her magazine. She says, "I can always put text in around the bird or do a bit of cropping to make it work in the magazine." Today's cameras produce

I was in my blind waiting for this Crested Caracara to do something. I had my portraits, but wanted more. This photo was taken shortly after the bird defecated, my signal that it might fly off of the branch soon. You can see how photographing the bird with its wings up helped fill the frame.

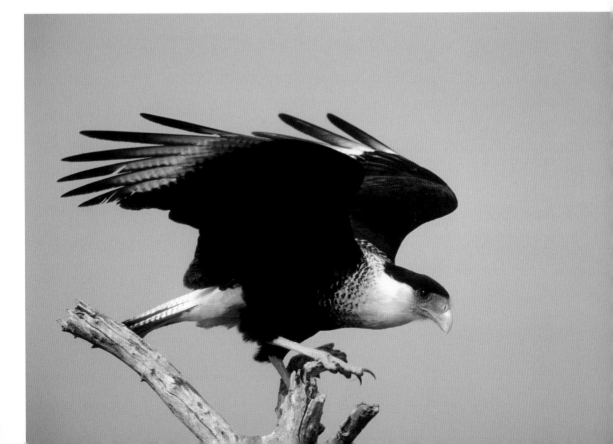

high-resolution images, so you can shoot loose and crop in postproduction without a loss of quality. It can be difficult to add space around a subject in postproduction.

If you plan to submit images for the cover of a magazine or other publication, you will need clean space around the bird so the text will show up nicely. Be sure to leave some space up top and along the sides when composing.

A portrait might include the whole bird or just a part of the bird. If you are too close to fit the entire bird in the frame, where do you crop? A head-and-neck shot is an option. You could also go extremely close and include only the eye and beak. Don't cut off the feet, the tip of the beak, or a wing; otherwise, the shot probably won't look good. Dawn Hewitt says, "If the foot or tail is cut off, we won't even look at it."

Top-Ten List

There is nothing better than when everything comes together to create a stunning image. Here are my top criteria for incredible images:

1. Great light
2. Peak moment of action
3. In focus and sharp as a tack or not (e.g., pan blurs)
4. Elegant foreground and background
5. Compositionally strong
6. Beautiful plumage
7. Storytelling—your picture is worth a 1000 words
8. Sex (does it matter?)—male, female, immature, or combination
9. Cooperative subject
10. The perfect mind-set, in the moment and anticipating

A beautiful image is the goal of professional bird photography, and it is especially enjoyable and satisfying when that happens.

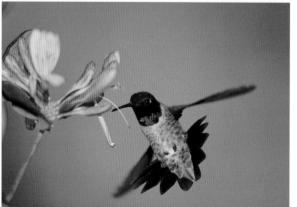

Here is how Dawn used my Black-Chinned Hummingbird. You can also see the original file. Note how she cropped and flipped the shot for the cover and added the text she needed. Notice, too, that when she cropped it she put more room above the bird for the magazine name.

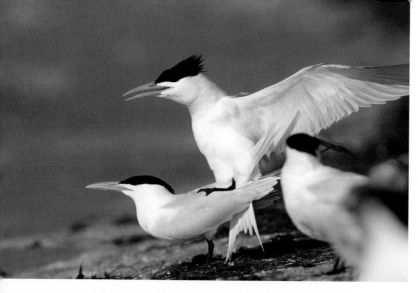

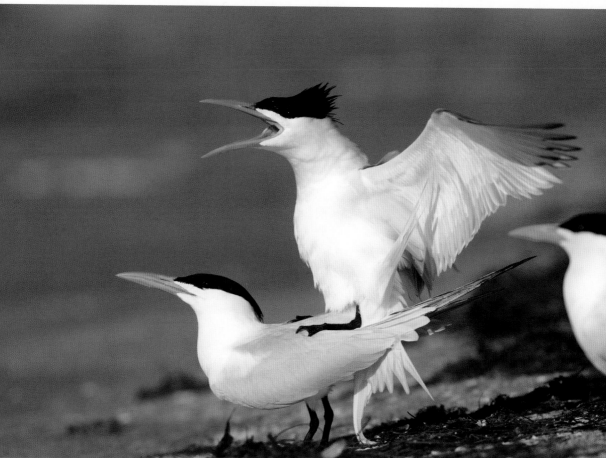

top left—What a great—but chaotic—scene! There were Royal Terns everywhere. I worked hard to get nice backgrounds and tonal separation between the birds and background, but they tend to flock together, so separation is not easy. When I got into the best-possible position for the shot, I was too close and, when the mating took place, I clipped the wing tips. There is an out-of-focus bird in front on the right and clipped wings on the male in mating position. **top right**—I was getting a nice, close vertical composition of this Royal Tern, but then my subject put its wings up for balance and I wound up with a cropped image. I still like the shot, though. **bottom**— Here, I was far enough away to shoot loose, thanks to the birds moving away from me and the flock. I didn't want to move too much and spook the flock after waiting for three hours. Which of these images is your favorite?

When you do cut off parts, cut off enough. A head-and-neck shot looks good, but a head, neck, and half a body usually doesn't. In the hummingbird cover Dawn used, she cut off the wing tips. Even though she won't look at a clipped photo, she may clip it for her needs. The lesson here is, get the image right in the camera and let the user make the changes they want.

If the bird's head is turned to the side, all parts will be sharp, even if there is minimal depth of field. If the bird is looking right at you or its head is at an angle, the entire head may not be sharp. So what are you trying to accomplish? What looks best to you? What looks best to an editor or other viewers? Remember, you are the artist, and you make the decisions. As a rule of thumb, though, keep the focus point on the bird's eye and, more specifically, on the catchlight in the eye.

Action and Behavior

Ethology, the study of behavior, is really helpful for photographers who capture bird action because actions are really *behaviors*. The more you know about bird behavior, the better prepared you will be to make the

top left and right—This Canada Goose was so cooperative at a city park that I put my 200mm macro on and crawled on my belly to a close position. One image is just a bit closer than the other. **bottom**—When birds wake up, they will often yawn. I waited for the action and was rewarded by this Canada Goose.

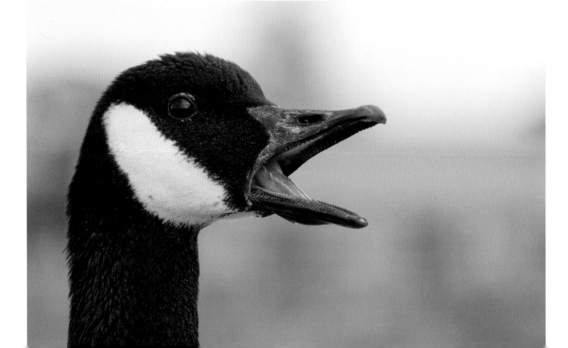

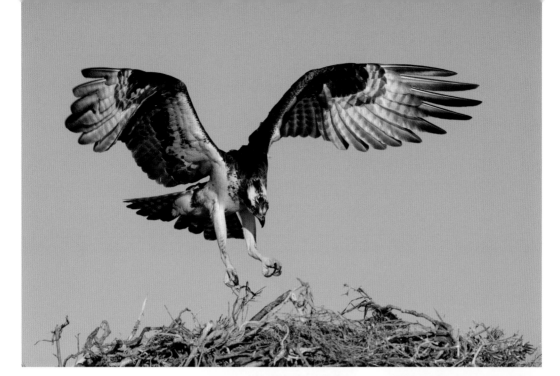

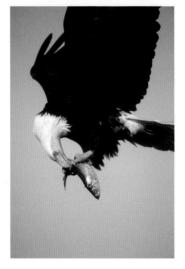

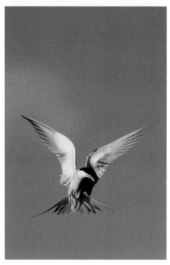

top—Osprey landing in a nest. This image also tells the story of the nesting season. **bottom left**—A Bald Eagle in flight, eating a fish. I was so close, but the bird was flying over me. What could I do but shoot, shoot, shoot? I love the image, even though I couldn't shoot loose and ended up clipping the wings. One of my photo tour clients won an award for a similar shot he got while standing next to me. **bottom right**—Forster's Tern in flight (actually, hovering). Flying is something birds do. Photograph it.

capture. Shoot loose, be ready, hope for a repeat of a behavior if you missed it, and stay a while. You will need to put in time and be patient and prepared to create great shots on a regular basis.

Adding something in the image that takes it beyond the category of portrait is important to me. A beak open can be from a yawn or a singing bird. A bird in flight shows what makes birds unique (they fly!), so show that behavior! Capture ruffled feathers, a bird preening its feathers, and feeding . . . you get the idea. Birds are very active, and that makes them great subjects.

When I am shooting action, I try not to hold down the shutter button and let 'er rip;

rather, I try to record peak moments with short bursts of rapid fire. This way, I can ensure the subject is in focus and the image is properly composed. When a bird yawns, it often tips its head back. So, if I am waiting for a yawn, I ensure there is space above the bird's head so nothing is clipped. As the head moves, the eye moves (of course), so I press the shutter button halfway to refocus, then make a series of exposures.

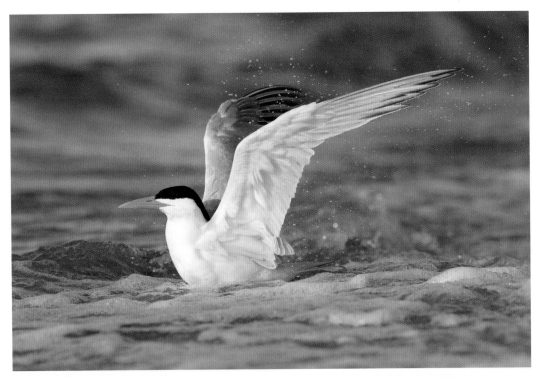

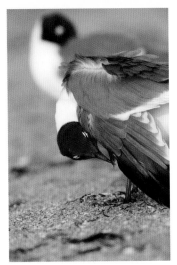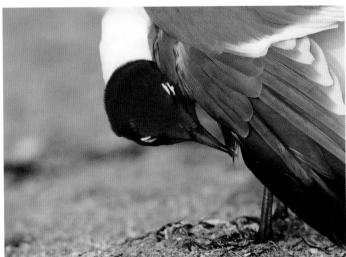

top—This Royal Tern moved out in the water to a good distance, and there were no other birds nearby. When the bird started bathing, I composed my shot to ensure that there was enough space to capture the flying water drops. **bottom left**—Here is a Laughing Gull preening. The background is too messy with the other bird, and I clipped off too much of the bird's back end. **bottom right**—This is the same image, cropped in. Notice how the quality changed by cropping. You can't see much loss in sharpness, but you can see how the composition was affected. I don't recommend this, generally, but it worked here. I crop all the time, but usually not this much.

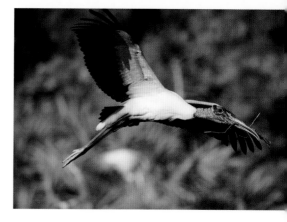

top—A clean sky also makes an effective background for an image of a Wood Stork. **bottom left**—This Wood Stork flew by clouds and trees that registered nicely for a pleasing background. The elements were far beyond the bird and appear blurred. As a result, the bird stands out. **bottom right**—This Wood Stork was flying by me. It was too close to the background, so the telephoto lens didn't render the trees totally out of focus. The background is too busy.

The mind-set in bird photography is typically to get close, then closer still. I'm guilty of that, too. Headshots are cool, and some amazing action shots are very tight, so don't stop creating them. However, it's good to shoot loose. When you do, there is room for action to happen, and you won't scare away the subject as easily. Shooting loose also forces you to look at the subject's surroundings and allows you to compose

 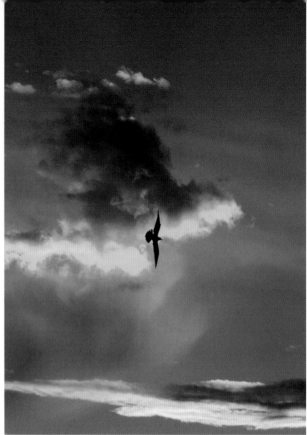

left—In this Sandhill Crane image, the trees and sky are nicely blurred and appear as washes of color. right—In this example, the background *is* the photo, and the bird, a Ring-Billed Gull, complements it.

artful images using the rule of thirds. Get in position at a distance where the bird will fill the frame if it wing flaps, and wait prepared.

Another benefit of shooting loose is when you are farther from your subject, the depth of field is increased, so it is easier to keep your subject in focus. A little movement at close range means a lot of movement for our camera to try to keep in focus.

If a shot is perfect in every way, save that there is too much wing clip, I will save the image because I can always crop in for a tight photo. If the beak is clipped, the image goes in the trash. Some people like adding beaks and such in Photoshop. If you choose

to take on a fix of that nature, show only your very best edited images and always inform viewers that the work was done.

Backgrounds: Looking Beyond the Bird

Backgrounds can make or break the shot. Find backgrounds that are pleasing, uncluttered, and colorful. A great background is just as important as the bird. Always pay attention to the background when you line up your image. If the background is far enough away, it will become a soft focus blur of color. If the background is close to your bird, make sure it will not be a cluttered mess in the image.

When you are photographing, pay attention to the environment and ensure that there are no elements in the scene that will detract from your subject. Move and shoot from another angle—perhaps one with fewer branches or more open sky—if it improves the overall composition.

When you are using a long telephoto lens, moving a few inches can change the background dramatically. Long lenses

top—I photographed this Greater Prairie-Chicken from a seated position. The background was too close to throw it out of focus. bottom—I made this image from a prone position. The background is more distant and appears much cleaner due to the limited depth of field.

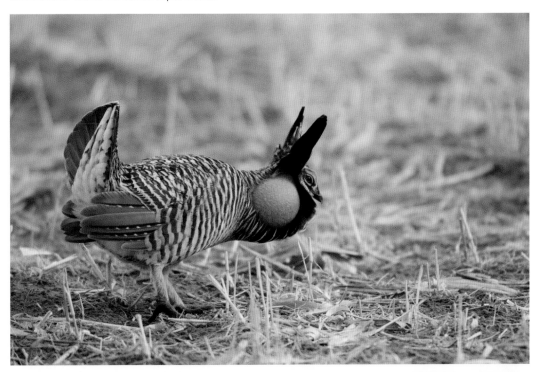

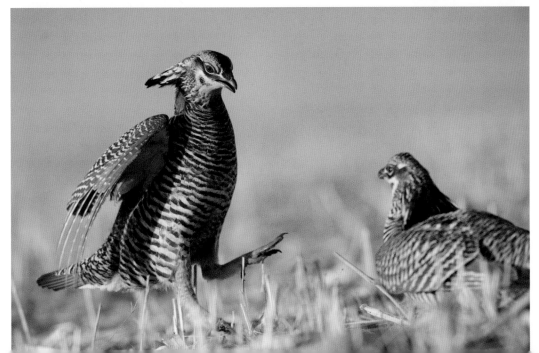

allow for a shallow depth of field, and this works in our favor for creating smooth backgrounds.

Perspective is another consideration. When I am photographing a bird on the ground, I get as low as possible. This allows me to let the scene behind the bird blur. When I shoot from a standing position, the background is comprised of the area immediately surrounding the bird, and it's impossible to keep the bird sharp and effectively blur the background. The background is too close.

Bird Scenics: Birds in the Landscape

When you compose "bird scenics," you need to take a careful look at what is around you and determine how you will use the surroundings in your picture. Then you must decide where to place the bird in the

image. Unfortunately, we can't tell the bird "Go over there, sit for ten minutes, then wing flap." You will need to put yourself in the proper position, be patient, hope, and enjoy the moment. If you can entice the bird to come to where you want it to with food or water, this can be helpful, too.

There are times when the scenery is beautiful and I will photograph it on its own merit, but I am always looking for a way to include an animal in amazing scenery to create a unique wildlife scenic. Birds are quite small and the scenery can be huge, so getting a great shot can be a challenge. Stay focused on finding a way to make it work.

When photographing eagles in Alaska, I focus on all aspects of the eagle's life history. Many of my favorite images show the beautiful Alaskan scenery with an eagle in the shot. Sunrises and sunsets are no-brainer scenics, and adding birds enhances them.

Crafting bird scenics is easier for those who use a 300mm or 400mm lens—or even a 200–400mm zoom. Using a shorter focal length forces us to view the birds from a greater distance and, in turn, we see more of their surroundings through the lens than we do when using a super-long lens. When we use huge pieces of glass, we seem to get in the "closer, closer, closer" mind-set. Close is fine. Just don't forget about stepping back, zooming out, and photographing the bird in its habitat.

Look at the work of Jim Brandenburg, Art Wolfe, or Tupper Ansel Blake. These masters of wildlife scenics have inspired me and helped shape my view of photography.

top—The Bald Eagle flew past the sunset. Awesome timing. **bottom**—Fog helps hold the colors of sunrise/sunset longer and adds ambiance to your shots. The Gull flying past the sun added interest in this image.

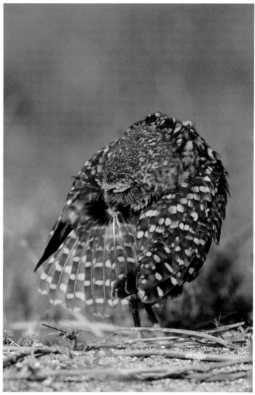

above—The Laysan Albatross is a seabird in a group of birds called tubenoses. You can see the tube and groove running to the tip of the beak. This adaptation allows excess salt to be removed from the body. **right**—The Burrowing Owl is using its uropygial gland during preening to maintain healthy feathers. This oil gland helps to waterproof and maintain the feathers.

Find the Unique

Another way to make your images stand out is to find the unique. Use a wide angle lens, a different technology, or a new technique. Show the part of the bird that makes that bird so amazing and unique. Albatrosses have the largest wingspan in the bird world; show them with their wings outstretched. Tubenoses can drink seawater. They remove deadly excess salt from the water using a special gland located near the eye (likely evolved from reptiles), and the salt waste is excreted through their tubular nostrils. This unique feature could be shown and used to teach people about these amazing creatures. How about showing the oil gland being used during preening? The uropygial gland helps to oil and waterproof bird's feathers. Why not show hummingbirds with their wings blurred? Why do we have to photograph them in perfect light with "frozen," non-moving parts? Maybe we should come up with a new technique or way to show the most incredible part of flight. It could include some blurring, a technique I enjoy and will explain later. By researching and learning about birds, you will gain information that will lead to new and interesting photographs—and you can use those images to share your knowledge with others.

Flight: It's What Makes a Bird a Bird

Pan Blurs. If you want to create a dynamic, artistic image, panning to create a blur is an option. Panning allows for a blurred background and blurred moving parts of the bird, but when it is done correctly, some parts of the bird remain in focus. Digital

top—These blurred Sandhill Cranes benefit from a colorful sky background. I like this image. Though there is nothing in focus to anchor it, it's an artistic approach. **bottom**—I added fill flash to this pan blur of the Lesser Prairie-Chicken. The flash created a nice catchlight in the eye and helped freeze some of the bird. When using flash with long exposures, the quick burst of light will help freeze motion. However, you'll get a ghosting type of blur as the animal continues to move after the flash has fired and the shutter is still open.

A small percentage of your images are a success while panning, but the ones that work can be stunning. Keep at it. With a digital camera, you can check your captures instantly and make any necessary adjustments. Maybe you need to adjust the speed at which you are panning to better match the bird's speed. Maybe you need to change the shutter speed to $1/30$ or $1/8$. Make the adjustments, take the shot, then check your LCD to gauge the results of the bird's movement and the way the background appears.

Panning can be a good option when you are photographing a bird against a busy background or if there are too many signs of humans. Sometimes I skip panning and opt for a long exposure. I find a nice setting, frame the shot, and record as the birds move. The longer shutter speed creates a fun blur across the non-moving setting.

Freezing Motion. The shutter speed you will need to freeze the motion of a flying bird will depend on the speed at which the bird is moving and your distance from your subject, but a shutter speed of at least $1/1000$ is a good starting point. I try to shoot at $1/2000$ when conditions allow and sometimes

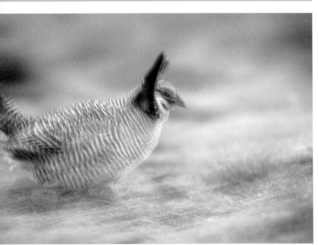

technology makes the technique easier. Set the shutter speed at $1/15$ and pan with your subject. To pan on a tripod, you will need a loose side-to-side motion so you can track the bird at the speed at which it is moving.

go as high as $^1/_{4000}$. Keep in mind that your distance from the subject will impact your shutter speed selection. When you are close to the bird, it appears to move faster in relation to the camera, so a faster shutter speed will be necessary. Also, faster reflexes will be needed. If you are farther away or the bird is flying slowly, you will be able to achieve a sharp image with a shutter speed of $^1/_{250}$ second.

top—Why not let the water blur and keep some birds sharp? I kept the camera still as the Sandhill Cranes roosted on the Platte River in Nebraska. I cropped the image into a panoramic shape in postproduction. **bottom**—I panned to photograph this Sharp-Tailed Grouse as it ran off a competitor. The eye and beak are close to focused and the tail held focus, but the rest of the image is blurred.

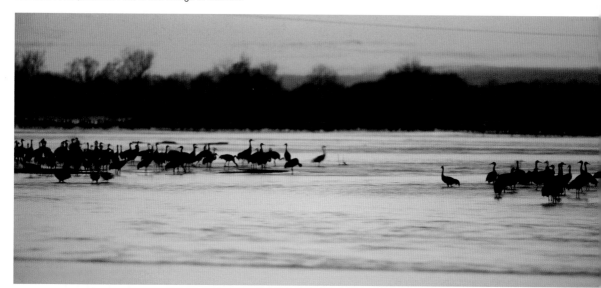

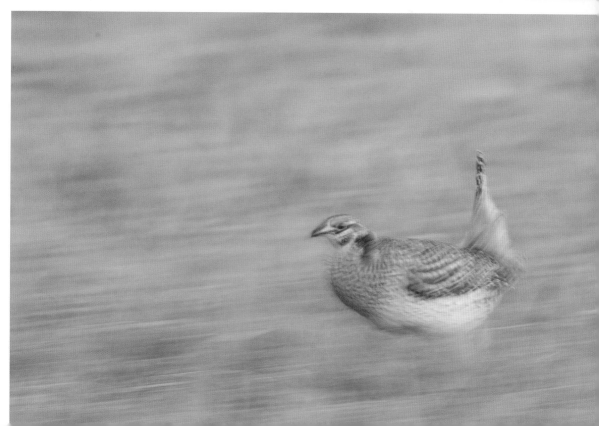

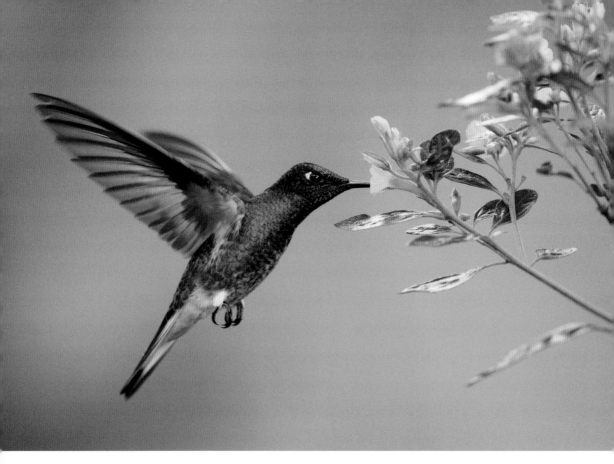

I shot this Buff-Tailed Coronet at $^1/_{2000}$ second to freeze the motion of the Hummingbird's wings.

I pan with the birds when shooting at high shutter speeds, making sure the camera moves at the same speed as the bird. I trip the shutter when I anticipate the movement I want to capture. With the camera set to AF mode, I can maintain focus on the moving subject and fire a series of images as the bird moves across the sky.

So, when do you fire the shutter? I like birds flying at me or in front of me, from side to side. What looks best—wings up, down, or straight out?—is a point of contention amongst photographers. A general rule of thumb is to capture wings in the upright or down position. I generally like a nice wing position, good light on the feathers, and the wing tips showing. Sometimes the wings straight out is nice too, and I really like cupped wings on larger birds coming in for a landing. What do *you* like when you see photos of birds in flight?

If you are photographing more than one bird in a scene, shoot when there is space between the birds so that they do not appear to be touching. Also, look for any patterns or nice lines the flock creates. When photographing flocks, a good graphic design element can be more important than the birds themselves. I like to shoot loose and leave room in front of the birds. If the

birds are angling upward, I leave space in front and above. This gives the appearance that the birds aren't flying out of the frame. When the action is fast, shoot fast, but look for diagonals, V-shapes, unique patterns, and any fun compositions.

A fast shutter speed is important, but there may be times when you need to reduce your shutter speed a bit so that you can select a narrower aperture that allows for increased depth of field—especially if you are photographing a flock. At the least, you'll want to make sure you have the eye of one bird sharp (let's hope it is one of the closest birds to you, or one of the lead birds of the flock). I put the AF sensor on one bird and try to stay locked on it while panning with the flock.

If the flock is flying by me from left to right, I put the focus sensor on the lead bird's eye in the group and compose so there is room on the right of the frame for the birds to move into.

If the birds get so close that a single bird almost fills the frame, I use the focus sensor on the right so the eye is behind the sensor as the bird moves from left to right. This helps keep the eye in focus as the bird flies by (because the bird's eye is on the right). All I need to do is concentrate on keeping the focus sensor on the eye. Everything else will take care of itself.

The sooner you can lock focus on the bird's eye and keep it there, the better the camera/lens will track it. I try to see the birds coming from enough of a distance that I can lock on focus long before they

top and center—Sandhill Crane with wings up and wings down. **bottom**—Snow Geese with wings out coming in for a landing.

top—I love the cloud shape with the White-Fronted Geese flying by. The lines are interesting. **bottom**—Wood Stork landing at nest with wings in the "angel wing" position.

are close enough for a good photo. This helps the camera "predict" the movement of the bird. If the bird is coming right at me, I keep shooting until the camera won't focus (with the focus sensor in the middle of the frame). If the birds are moving from left to right, I start shooting when I notice them and stop shooting when they are right in front of me. After that, I would get butt shots. If you want to get a butt shot, put the focus sensor on the butt and "spank" the shutter release.

top left—In this case, I had the focus sensor on the top bird's eye. This allowed me to leave space in front of the White-Fronted Geese. **top right**—Sandhill Crane flock with overlapping of the birds. Wait for the separation; it helps a lot. **bottom**—The Sandhill Crane flock has separated and is coming in to land with wings cupped. Just a touch of tree background adds a sense of depth in the image.

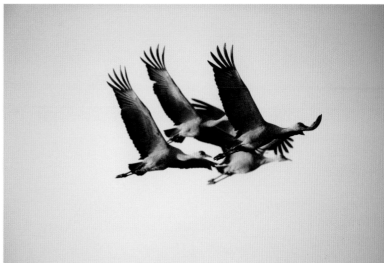

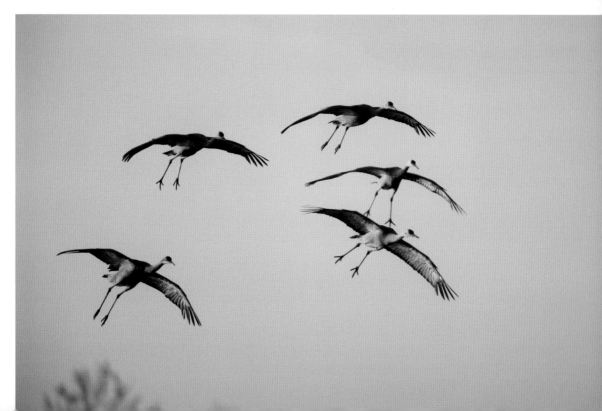

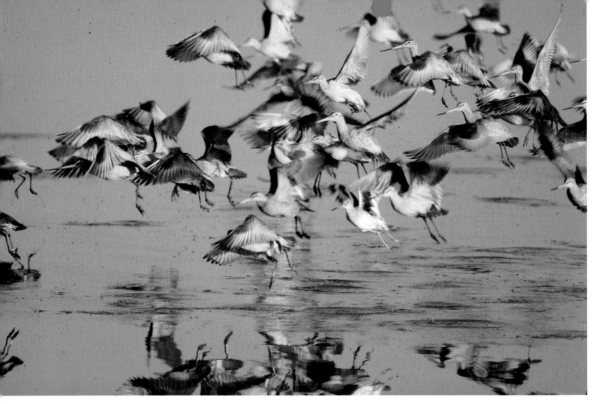

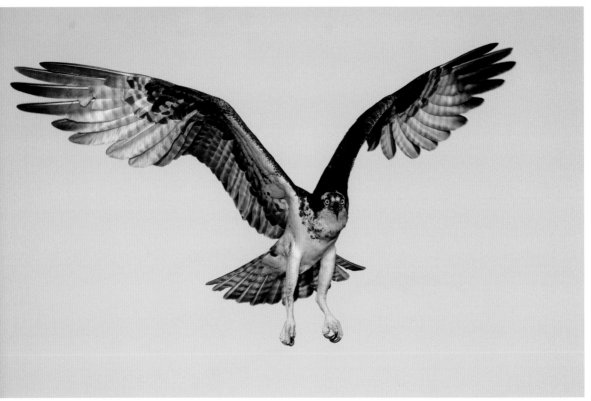

top—Marbled Godwits jumping up with a Willet. If you can catch birds taking flight toward you, it can be very exciting. Try to focus on the closest birds to you, or the lead birds in the flock. **bottom**—Osprey flying right at me. These shots are easy to capture with the amazing autofocus capabilities of today's cameras. **facing page**—This Osprey turned and created the resulting diagonal wings with beautiful light. Though you may have captured some great photos, if the subject is cooperative, keep shooting. You might get a pose that is better than the rest. Shooting vertical helps when the subject is vertical and you think you may have a cover image.

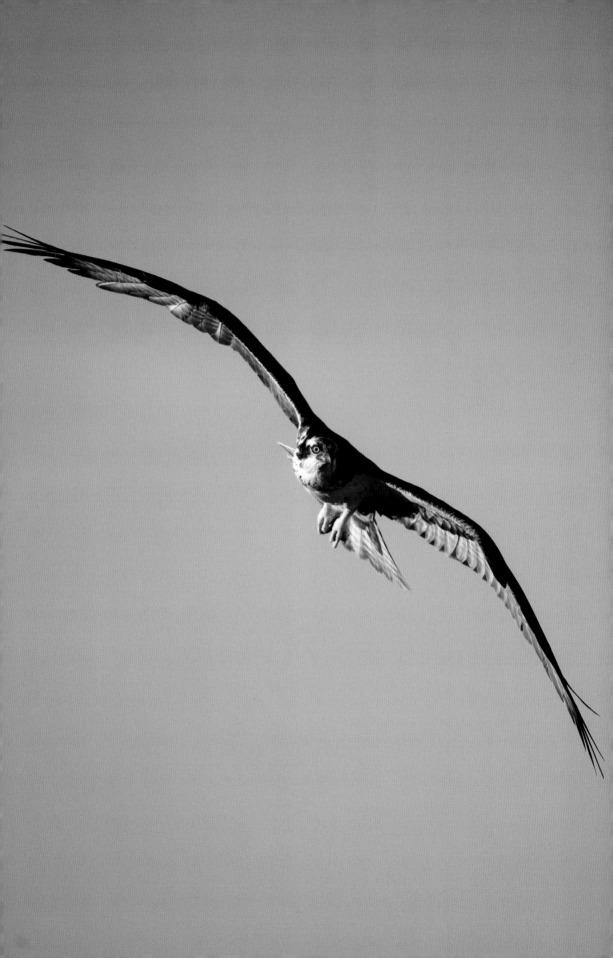

Perspective

One time I climbed up a cliff and shot down on the hawks soaring below me. I was getting the top of a Red-Tailed Hawk, the side most people don't see. Most people look up at flying birds, and most of the images the editor saw were made from that perspective. When my image came across his desk, it was unique, and he used it. In my opinion, it was just an average shot I had taken many years ago with lots of space around the bird, but it was the angle of view, or perspective, that made it unique.

When shooting ground-dwelling or close-to-the-ground birds, lie on the ground. It can take a wildlife photo from average to professional. My neck has hated me after hours of lying prone, looking through the

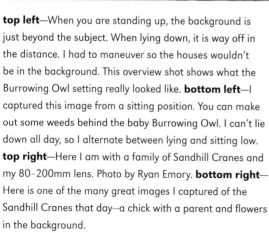

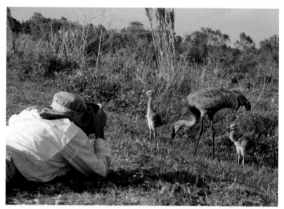

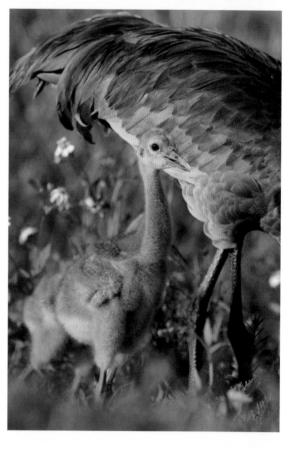

top left—When you are standing up, the background is just beyond the subject. When lying down, it is way off in the distance. I had to maneuver so the houses wouldn't be in the background. This overview shot shows what the Burrowing Owl setting really looked like. **bottom left**—I captured this image from a sitting position. You can make out some weeds behind the baby Burrowing Owl. I can't lie down all day, so I alternate between lying and sitting low. **top right**—Here I am with a family of Sandhill Cranes and my 80–200mm lens. Photo by Ryan Emory. **bottom right**—Here is one of the many great images I captured of the Sandhill Cranes that day—a chick with a parent and flowers in the background.

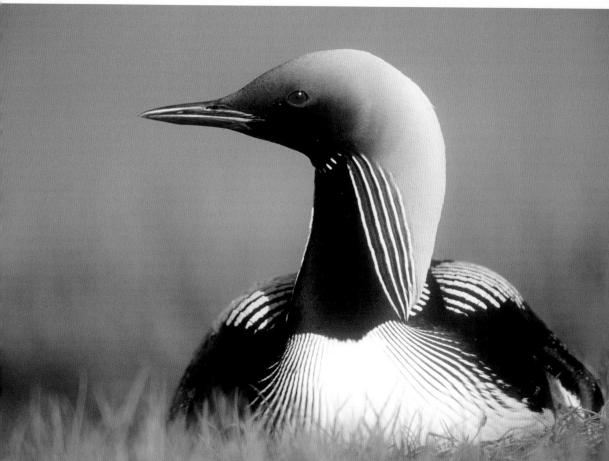

top left—I captured this image from a prone position. Note the way the background blurs. I cut off the chick's wing because I was too close. The adult is totally fully visible, though, with a foot up, and the head of each bird is in the frame, so I'm okay with the clipping in this case. **top right**—The background for this glorious male Wood Duck is water, with red leaves reflecting in the pond. Reflections pop when the background color is in the sun and the water is in the shade. Added flash produced a catchlight and brought out the bird's color. **bottom**—Here is a unique view looking up at a Pacific Loon. I shot from the water level and the bird was on a nest on the shoreline.

camera, but my images are better for it. My chiropractor is my best friend after such a shoot.

When you are standing up, the lens is pointed down and the background is just inches beyond the bird. When you are lying

top—The Tropical Kingbird landed on this branch, and there was a pink flower in the background. I had to move a couple inches after I set up to get everything aligned. If I were a couple of inches to the left, the background would have been gray. The flower was in the sun, so it popped; the bird was in the shade and needed a touch of fill flash. **bottom left**—This drake Mallard photo has many great elements, including beautiful colors, water drops, and reflections. My low angle (on the ground) enhanced the background blur. **bottom right**—This is a fun image of an adult Burrowing Owl digging out the burrow and the sand hitting the little guy. I spent two days photographing when the birds first came out of the nest, then went back a week later for a day. This allowed me to show how the chicks had matured.

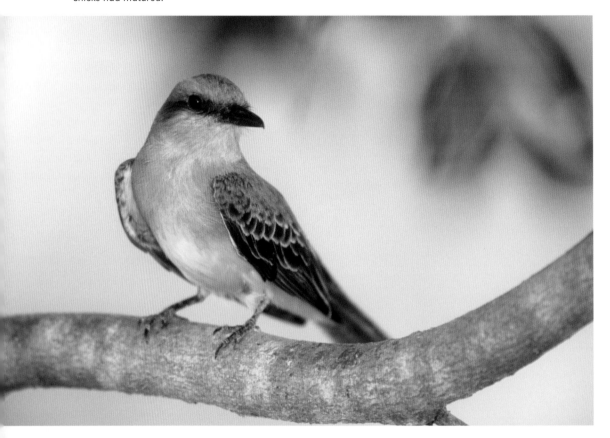

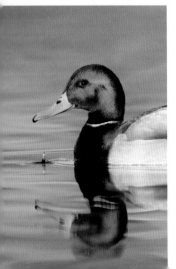

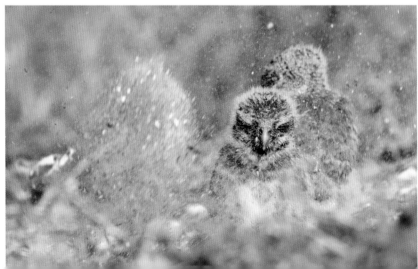

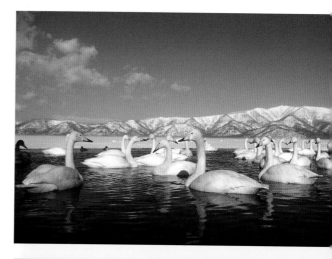

top—The Whooper Swans on Lake Kussharo in Japan were cooperative. I photographed them with a wide angle lens. **bottom**—Visits by humans to city parks and other places make birds easier to approach and more cooperative. This Wood Duck was swimming through beautiful reflections.

down, the background is farther off in the distance and will go out of focus, and you will get a soft, sweet blur. Sometimes when you are on the ground the lens might even point upward slightly. This will present a unique angle—something your viewers or photo buyers do not often see. If you are able to shoot from a low enough angle, you can even get some blue sky in the background or another nice color off in the distance. That will make the background a beautiful setting for your subjects.

Besides the unique angle, soft background, and potential color, lying prone will make your body appear smaller and less human, so you may not scare the birds as easily. My favorite part of shooting prone is the ability to be at the bird's eye level. When your viewer sees the bird at its eye level, there is a stronger connection. Eye contact is a huge plus, and eye contact at eye level is even more wonderful.

Backgrounds are important, and using a long lens compresses and compacts the view. When I find my subject and shoot from a low angle, I always check to see how the background will appear. I look for colors like a green field or a group of trees, maybe in fall color. Sometimes moving just a couple of inches will yield better results. Also, if the background is far enough from the subject,

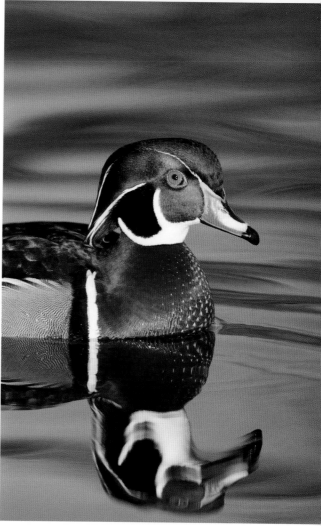

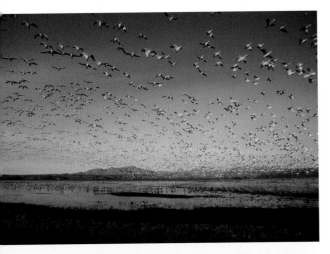

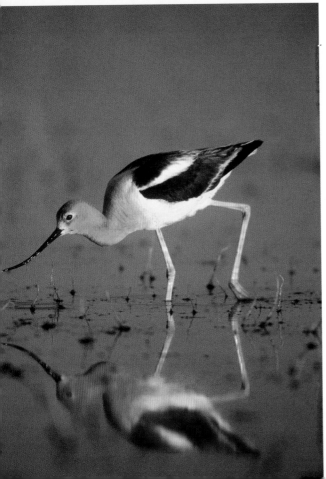

the focus will fall away. If you are making a bird scenic, though, you may want to ensure that the background elements are sharp enough to be discernible.

When you frame your shot, pay attention to the foreground. You don't want a weed or branch across the face of your subject. Eliminating a distraction is often as simple as moving an inch or two to the left or right.

Cooperative Subjects

Like people, birds have individual personalities, and some are more tolerant than others. If you find a bird that allows you to photograph and get close, don't just snap a portrait and move on. Stay and capture behaviors and other exciting things the bird does in its natural state. Make images of birds being birds. Birds that aren't stressed by your presence are worth more of your time.

Sometimes you can foster cooperation by presenting a feeding station or water hole. When birds are busy eating, drinking, or bathing, they are distracted and often more tolerant. Also, there are many locations where the birds are used to people. These hot spots are a great place to capture some "easy" bird photography. Many of these places are listed in chapter 10.

Cooperative subjects can also be found in local parks, campgrounds, hiking trails, and other areas where lots of people visit. I am a fan of the National Wildlife Refuges (NWRs), land federally set aside to "protect" wildlife. Some refuges allow hunting (you know, "protecting" wildlife);

in those cases, the birds may be more skittish, and you may have to work a bit harder for wonderful photos.

Photographing close to home is a good option. You can visit nearby locations many times throughout the year, in different seasons, and really get to know the landscape and animals. This intimate knowledge will lead to better images and more opportunities. Specializing in a location or a species will also help you and your photos become known—which is important if you plan to sell or share your photos. Bosque del Apache NWR in New Mexico and J.N. Ding Darling NWR in Florida are two very photographed refuges. I like to go there, but I also like to go to the lesser-visited refuges. My favorite is the Klamath Basin NWR complex because it is close to home and there are great opportunities. Not all the birds are very cooperative there, though, as hunting is allowed at that location. I know the space intimately, and that gives me a clear advantage.

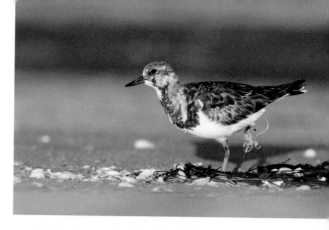

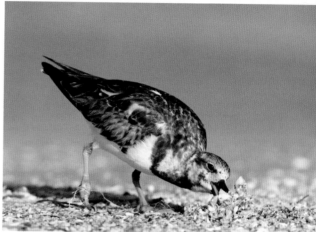

top—This Ruddy Turnstone is in eclipse plumage, midway between winter and breeding colors. It has a string wrapped around its leg. This kind of picture needs no explanation; it is definitely worth 1000 words. **bottom**—The string didn't seem to bother the bird too much, as it was able to turn stones just fine. But I'm sure that foot didn't feel too good, as the bird *did* limp.

Photojournalism: Telling a Story

Becoming a photojournalist—telling a story—will bring added meaning to your images and can increase the saleability of your work. One way to tell a story is to include people in your photos of birds. For example, I decided to tell the story of a rancher who owned a cattle ranch historically populated by Lesser-Prairie-Chickens. The rancher wanted to bring the birds back and did so—using some surprising, innovative tactics. He created a new lek on his property and amazed even the local chicken biologists. I got great shots of the chickens, then photographed the rancher and documented his techniques.

Some of my favorite storytelling sequences, and the most lucrative ones, deal with the life cycles of animals. For the birds, it means recording them from nesting to adulthood, with interesting behavioral

(storytelling) shots in between. So I give myself these projects as "self-assignments" and then work toward making a life-cycle sequence. This involves more than one shot. Sometimes it works out that I can make a good story in a few days. Other times, like when I set a goal to create my book, *Bald Eagles in the Wild,* the work takes years. I regularly work toward creating new images that might be added to that collection. In the process, I have sold many eagle shots.

When creating stories, I also capture photographs of the bird's habitat, surroundings, and the creatures that interact with my target species. Think like a storyteller when you are planning your photographs. Take a look at magazines that use these kinds of stories as you conceptualize your own. *National Geographic* is the leader in this genre, but *National Wildlife* and *Audubon* magazines do a nice job, too.

left—Kenny Knowles put up Lesser Prairie-Chicken decoys and played their mating calls. The local experts laughed at him, but it **worked.** I decided to include him in my story about the birds and their recovery. **below**—Here is one of many life cycle images from my Eared Grebe collection. The adult is feeding a new chick whose red spot (on the top of its head) is showing.

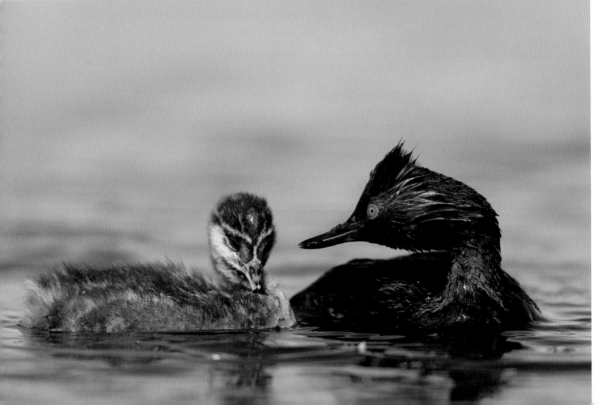

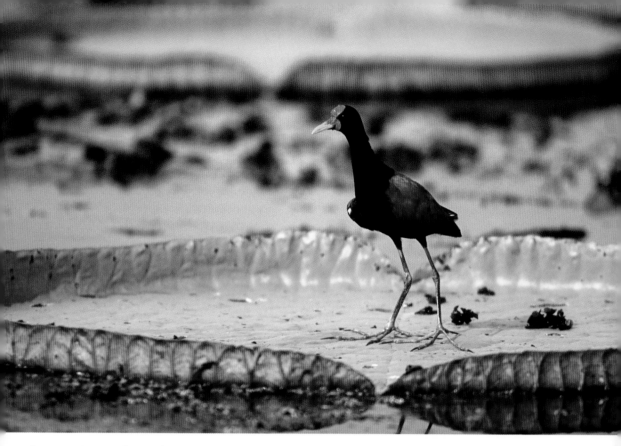

For a story I was working on for **Nature's Best** magazine about Brazil's Pantanal, the giant lily pads were just one of many unique subjects. The Northern Jacana on a lily pad, in its habitat, gives a sense of the bird's size.

Think local, look for stories close to home, and become the expert. You may be able to help save a species or habitat by telling your story. Give presentations to local organizations, sell a story to a magazine, or post your story on the Internet. There are many ways to share your stories. If you have the passion, you will succeed.

Blinds

Using a blind will often allow for the capture of some unique photos. In places where blinds aren't necessary, like Bosque del Apache NWR in New Mexico or many places in Florida, the photos are very similar to everybody else's. It is more difficult to work in locations where blinds are necessary, but such locations present amazing and unique opportunities. When you are in a blind, the birds often relax because they don't see you or your movements. This is another way to create a situation in which the bird will be more cooperative.

Movement can spook birds and make them skittish. There are numerous kinds of blinds available, and many situations to use them in. A blind doesn't need to be an expensive, elaborate thing; it can be as simple as a cardboard box. Remember, we need to break up our human form and not allow our movements or the movement of the blind to scare the bird. Of course, a box

top—These Northern Rough-legged Hawk chicks were hungrily awaiting the vole that a parent had just brought in. Raptors are especially bothered by people near their nest, so shooting from a blind is best.
bottom—Here is my terrestrial blind setup looking down at the Rough-Legged Hawks' nest. If you look closely, you'll see a white spot below the blind in a stick nest. Those are the babies. Once I got the blind in position, I left it up and photographed every couple of days as the chicks grew. Creating a life-cycle sequence allows me to share many stories.

won't work in all cases, like when it starts to rain or the wind begins to blow.

Portable Terrestrial Blind. A portable terrestrial blind goes everywhere easily. Throw a piece of material over your body, and you have made a simple throw blind. These are quick, easy to use, and often effective. I have used them with much success, but prefer a bit more cover for long stretches of time.

Having started my photography career as a poor college student, I was always searching for ways to make a blind that I could afford. I modeled my blind after John Shaw's design; he used a projector stand and covered it with cloth material.

My blind consists of a piece of plywood with PVC legs attached that can swivel for more angle. My cover is a cheap but durable material. A camouflage pattern isn't necessary. If you are photographing in snow, a white cover is a good choice. If the cover is thin and the sun is at your back, the bird may be able to see your moving silhouette. Therefore, I attached a black liner to my blind cover.

I made a slit down the front and added Velcro so I could adjust the "elephant nose" *(see the image on the next page),* a piece of material that fits snugly around the front of the lens but allows you to reach in and access the lens controls. I can move the lens up or down, depending on the situation. I like to shoot from a low position whenever I can, so the slit goes almost to the ground. It also goes high enough so I can sit or stand when the need arises.

top—(left) This open view of my portable blind shows how it is made. PVC pipe legs are attached to a plywood top, then covered with cloth. The PVC legs are made with a straight connector between every 3 feet of pipe. I do this so the blind fits in my suitcase. Also, this makes the blind height adjustable. (right) Here, you can see the unique front opening with the Velcro slit. I can Velcro the fabric closed around the front of my lens at any height, or leave it open if the bird isn't bothered.

center—The blind setup showing the "elephant nose" front, which has elastic that goes around the front of the lens. The part of the elephant nose that attaches to the blind is secured by Velcro, and I can get the blind sealed up tight if my subject is wary.

bottom—(left) A close-up of the elephant nose. (right) The blind's plywood top is 18x18 inches and the PVC legs are adjustable to different lengths depending on if I will be sitting or standing. I usually have it about 5 feet tall (2 of the 3-foot lengths at an angle makes it about 5 feet tall) so I can sit or lie down. You can see I have added a hole for a handle to carry it. The PVC brackets are bolted to the top. I have the T bracket with two screws through the top but am trading them out for the swivel bracket I made, which is more durable. You can see the swivel bracket at the bottom right of the image.

This blind is lightweight. I have flown all around the world with it.

I have lived in my terrestrial blind for two days at a time. At night, my legs stick out in my sleeping bag. When spending the night, be prepared with everything you'll need. Going to the bathroom is a challenge; a container helps with that. I need to spend the night only in hard-to-get-to places or situations when not disturbing the birds is important. For example, I once set up my blind at night to photograph an eagle nest. Raptors usually won't visit the nest with young in it if a person is standing nearby. They will just fly around angrily, trying to

top—You can see how the Groofwin attaches and how sturdy it is with large glass. I can let go and not worry about my camera falling off. bottom—Here is my camera setup on my truck window. Notice the bird dropping on the door. How appropriate!

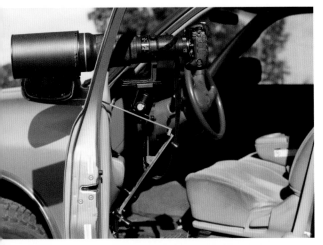

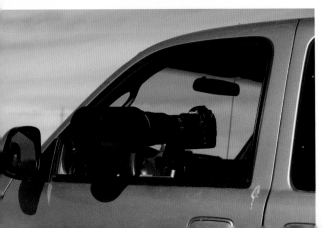

make you leave. I wanted a unique shot that showed the adult in the nest with the chick. The weather didn't cooperate, but at least the birds did.

Portable Movable Blind: Using Your Vehicle. When photographing in NWRs, cities, and other populous areas where there are lots of vehicles, birds become accustomed to traffic, and staying in your car can be the best way to find a cooperative subject. Some of the refuges actually require you to stay in your car so that you will not spook the wildlife.

Driving slowly, about 15 to 20mph, gives you time to spot birds and stop. Don't be herky jerky; birds don't like sudden movements. I gradually pull off to the side of the dirt road and stop. Pulling over allows traffic to flow so you can photograph as long as you want. There is nothing more frustrating than finding a great photo op and having traffic backed up behind you. When I spot a subject, I pull into range with my camera/lens already set up out the window (again, less movement) and move slowly. My side mirror is pushed out of the way to provide more room.

Some places allow you to get out of the car. In those cases, I get the shot out of the window, then slowly get out and get low if the bird is lower. It is really nice when the birds are already at eye level (say, on top of a bush) and you can stay in the car.

When photographing out of my truck window, I use the Leonard Lee Rue Groofwin mount with an Arca-Swiss ballhead attached to it. It's a great mount.

There are many different brands of mounts available, so look around, research what might work best for you, and try to put your hands on it and "test" it before you decide what to buy.

Floating Blind. The floating blind is my favorite. It's quite unique; it allows my lens to be just a foot above the water level, so I can capture images from a low perspective. There are many designs out there, and you should tweak them to suit your needs.

The first floating blind I built was a wooden box made of 2x2-foot boards. I built it around an inner tube, and it was about 3x3x3 feet. If you are wearing chest waders and standing in the water, you only need to cover your head, shoulders, and long lens with the blind. Of course, you must be safe and keep your gear protected while in and on the water. I try to use my blind in shallow areas where my feet can touch the bottom. This gives me more control and stability. I am most comfortable when I can sit with my legs down and touching the bottom and there is no wind.

The floating blind I use today is a fisherman's float tube with a camouflage cover. (Fisherman's float tubes come with a seat and are designed to keep you dry while wearing chest waders.) The blind cover has a slit Velcro design that allows the lens to be moved up and down and side to side.

When I'm in my floating blind with warm enough water and a bird in range, I am happiest. It's a Zenlike feeling, and I am in the moment. It is so fulfilling to come out of the blind with a card full of bird images

top—This design was inspired by an article Keith Szafranski wrote for *WildBird Magazine*. The blind is shown here with the front wide open. **center**—You can see the fisherman's float tube with the platform and the black tube pipe ring that holds the cover in place. The cloth is held up by PVC pipes, which go inside the black base pipe. The platform I made has a mount for my ballhead. You can also see the wooden dowels I drilled into the black pipe to secure the camouflage material. **bottom**—Note the black tube and the pocket where the PVC attaches. To make this, you will need help from a seamstress.

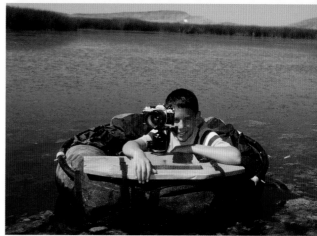

from water level. It's not easy to learn to use a floating blind, but when it works, the images are just beautiful.

Sometimes my waders don't keep me dry, so I go in prepared to get wet. I like to get the lens down low for an eye-level view, and that causes water to fill my waders. When using a blind, my comfort is important—especially the older I get. While I have a high tolerance for discomfort, I am able to work longer and stay focused on making images when I am comfortable. With this setup, even if I get wet (in warm weather!), I am comfortable.

I have custom designed my blind for my body size and comfort. Inside, there is a shooting platform that I can put my ballhead on. I keep a waterproof bag filled with snacks, my diabetic supplies, water, extension tube, tele-extender, and whatever else I may need for the shoot. It all rests on the platform.

Where to Place the Blind? When thinking about shooting locations, realize that there has to be a reason for the bird to be in front of the blind. I look for areas in which there are a lot of birds feeding, resting, or hanging out and place my blind there. Sometimes I position my blind, leave, and come back the next day. Other times, I set it up, get in, and wait for the birds to return. If you are shooting in an area where the birds are accustomed to people, a blind isn't necessary. In areas where they are skittish, a blind is a big help. When I am driving in a refuge or public place, I am on the lookout for a place to set up a blind. If I am working from my car in a wildlife area tour route (one that allows blind use), I will drive around and look for locations the birds are constantly using.

Comfort. When photographing from blinds, comfort is key. I am a squirmer, and I am always trying to find a comfortable position. Working in a blind masks your movement so you can stay comfy. You might also consider outfitting your blind with a chair with a back on it that is the correct

left—This shows the PVC leg in the pocket, which is sewn to the fisherman cover. right—This picture shows how the PVC pipes go through the material on the inside of the blind.

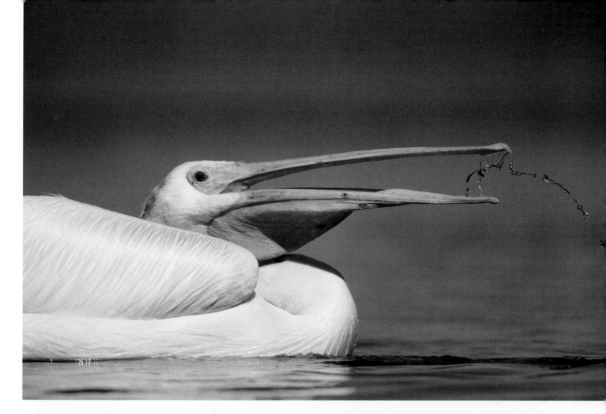

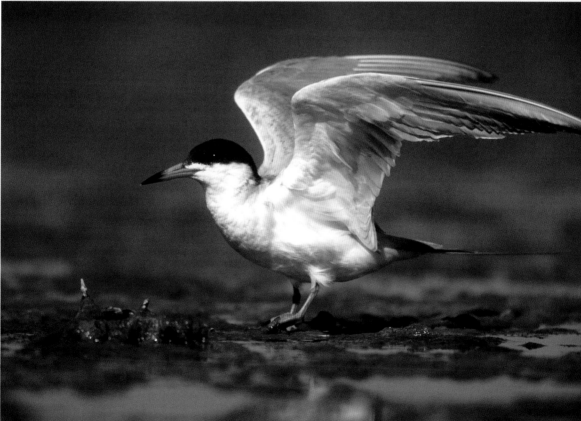

top—This image of an American White Pelican eating was taken from my floating blind. I couldn't back up here, so I couldn't shoot loose. However, I still managed to include the head and some body to hold the composition well. I do love tight close-ups with action. **bottom**—Forster's Tern, wings up, photographed from my floating blind. Notice the eye-level view. Birds are often more tolerant when we approach them from the water, as most predators come from the land.

height for shooting. This can help your back. Dressing for the weather is crucial. If you are too cold, you won't be able to make great images for long. When photographing in the winter and sitting still in a blind, you'll need to wear layers. I have even used my sleeping bag to help warm me. When walking around, your body generates more

top—A cold morning in Alaska. Being prepared allowed me to stay in the frigid conditions and get the Bald Eagle shots. I love to photograph in the snow. I like to find a dark background so the flakes show up in the image. **bottom**—A flock of Sandhill Cranes. This photo was captured from a permanent blind along the Platte River, which is a hot spot when the cranes are using it in spring. I've been building up a good storytelling life-cycle sequence of the Sandhills. I've photographed them at a number of places across the country.

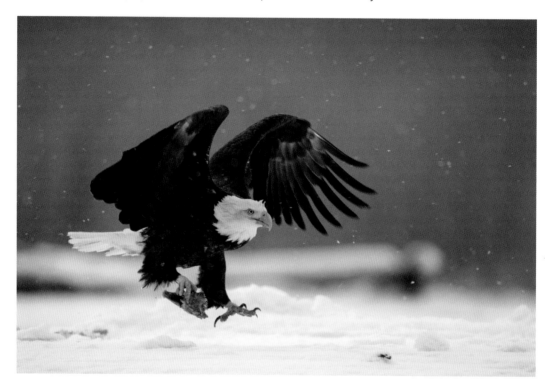

heat, so dress appropriately and peel off some layers.

In the summer, wear lighter clothing, stay hydrated, and take all the precautions to be as comfortable as possible. Photographing outdoors means dealing with what Mother Nature throws at you—whether it's punishing heat, wind, or rain—and maybe even bugs and snakes. The better prepared and more comfortable you are, the longer you will be able to stay outside photographing.

When using a blind, you want to be comfortable, conceal your movement and body shape, and keep noise to a minimum. The longer you are in the blind, the more the bird will become accustomed to you and you will "become" part of the habitat. That is why I often position my blind and leave it set up for a few days or weeks.

Permanent Blind. Building or placing a blind in a permanent location can be useful because it becomes part of the habitat and the wildlife will ignore it after a short time.

Permanent blinds come in all shapes and sizes. They can be anywhere—on land, water, or underground. Some are pits; these allow you to place your lens at ground level.

The downfall to a permanent blind is there might not be any birds in front of it. If you are building a permanent blind for use in your yard, place a feeding station in front of it and keep it stocked seasonally or even year-round. Water is also a draw for birds.

If you go to a refuge or other public location where there are blinds set up, make sure they are designed for photographers. Do some research to ensure it's likely that there will be birds in front of the blind at that time of year. Every place is different.

Digiscoping

The practice of attaching a camera to a spotting scope is called digiscoping. Many birders already own or plan to purchase a spotting scope. The device is essentially a super telephoto lens when attached to a camera. The only gear you will need is a good tripod and an adaptor that mounts your camera to the scope. Each camera and spotting scope have their own specific adaptors. Be sure you get the one you need for the gear you will be using.

Making identification photos is very important in the birding world. These images are used to determine rare species and birds found in areas where they normally aren't seen. A digiscope can be a great tool to use to capture these shots.

I have seen many photos published in birding magazines that were taken via digiscoping. If you want to use a spotting scope to make beautiful, artful images, then using the techniques in this book will help greatly.

A word on technique: A 20x spotting scope is equivalent to a 1000mm lens, so you will need to use good technique and a sturdy tripod to capture sharp images. The quality of the scope and camera's sensor will have a big impact on your photographic results.

Consider your intentions for your images before purchasing a scope. If you're primarily interested in making identification photos, there may be no need to invest in a pricey, top-of-the-line scope.

6. FINDING BIRDS

Birds can be found anywhere there is food, shelter, and water. From the countryside to the big city, all around the world, there are birds to be photographed. The Arctic Tern, for instance, flies from the Arctic to the Antarctic and back every year. That is about 20,000 miles per year! In the summer, they are up north nesting, and in our winter they are having summer again in the southern hemisphere. These birds literally fly around the globe annually and never experience winter. They are true "snowbirds" following the "good weather."

Birds—and their adaptations—are amazing. Mating rituals and nesting behaviors can be bizarre and extreme. These are often the best photo opportunities. Breeding grouse on their lek provide a great photo opportunity. The males fight and the females will choose their mate. Bowerbirds are fascinating, too. They decorate their nest with objects of a specific color that they find.

I have photographed birds in the city and in the remote corners of the world, and the challenge is always the same: to make a beautiful, artful image of our avian world and one that tells a story. If your picture is worth 1000 words, then you've made a successful image.

In my town, the Brewer's Blackbirds nest in stoplights. I finally found one nest light that I could safely get close to. It had a vantage point from the sidewalk, and I could shoot to my heart's content. I did have to deal with horns blaring at me. A guy standing in the street with a 500mm lens pointed at a stoplight is not a normal city sight.

I have photographed pigeons in Venice, Italy; cranes in Japan; sparrows in my backyard; and blackbirds nesting in downtown Redding, California. Costa Rica and the Galapagos Islands are also hot spots. So where do you want to go, and what species of bird do you want to photograph?

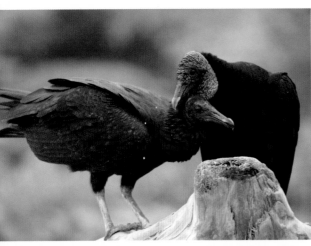

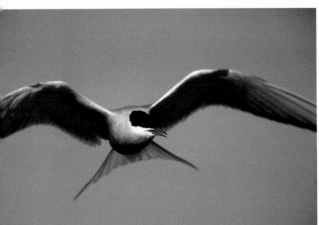

top—Black Vultures allopreening. This behavior makes for great interaction photos. **bottom**—An Arctic Tern in flight. These birds fly around the world every year.

Become a Photonaturalist

Aside from mastering your technical skills, the best thing you can do to improve your bird photography is to become a naturalist. Learn about your subjects inside and out. A wildlife photographer is really just an ethologist—one who studies behavior. Studying behavior will help you realize what action is happening and when it is about to happen. I have a bachelor's degree in wildlife biology and specialized in ornithology, but all you need is passion and the desire to learn in order to succeed. I know many great birders and bird photographers who have learned about their subject without a college education. Getting behind the lens is the most fun way to learn, anyway.

Knowing the 5 Ws—who, what, when, where, and why—as they apply to your subjects will help you capture the best-possible images.

- *Who*—Know how to identify the bird.
- *What*—What behaviors are being exhibited?
- *When*—When do they feed, roost, loaf, rest, and breed?
- *Where*—Where do they live? What are their migration patterns?
- *Why*—Why do birds do what they do?

The more you learn about birds, the better images you will create. The more great images you create, the more you will become a photonaturalist, because you will also be learning while you photograph. I particularly enjoy learning through the lens.

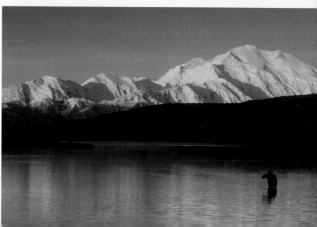

top—A bird nesting in something manmade provides a good opportunity to capture a storytelling photograph. I think the warmth of the light was a bonus to the bird's comfort. This kind of photo sells, and this Brewer's Blackbird picture has been published more than once. **bottom**—On a trip to Denali National Park, I was photographing everything, including the birds. I spent two weeks in the park and saw the mountain only twice—at sunset and sunrise. Thank you, moose.

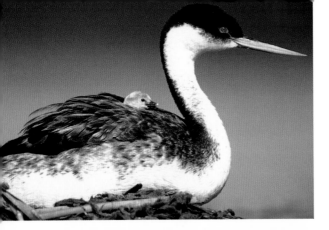

One memorable lesson I learned through the lens while photographing a Western Grebe nest will stay with me forever. The egg just hatched under the mother Grebe, and the new chick began climbing out from under to get on mom's back. I knew these birds carry their young on their backs, and I wanted to capture that very cute shot. What I learned was what happened next.

As the young began its long journey from under mom to the top of her back, the adult Grebe put her foot out as a step for the chick to get on, then pushed the baby up on her back. She used her foot like an elevator to get the chick "on board."

I thought this behavior was amazing, and I never would have known it existed had I not been there the day the chicks hatched. My photograph of the behavior is not great, but the experience was. I had spent days at the nest and was there at the right moment—one very few people have witnessed. Being a photonaturalist helps me enjoy all that I learn while watching and photographing the animals. This intimate knowledge helped me create many great and unique shots of the Grebe's life cycle.

Being open to photograph what is around you and making photo stories or taking a

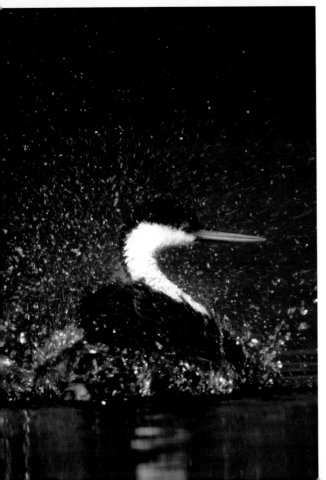

top—Newborn on mom's back for the first time. I watched these Western Grebes build their nest and lay their eggs, so I knew exactly when they would hatch. You can find the incubation periods for any bird online. **center**—The chick just hatched, and the mother bird used her foot to lift it to her back. You can even see mom's feathers are ruffled and ready to house the chick. **bottom**—Western Grebe bathing. Being in close proximity to the family of Western Grebes for a long stretch of time allowed me to make many great images. This shot has been the cover of the Audubon birds calendar, and it is a great addition to my life-cycle image collection of Western Grebes.

journalistic approach to your photography helps you become a photonaturalist. You might even capture a photo of a subject that isn't a bird. I usually have the mind-set of photographing birds first, but I am open to whatever comes my way. Having a love of nature and realizing everything can be your subject are defining characteristics of the photonaturalist.

Know Your Subject and Location

Today, you can use the Internet and apps to access information on any topic. There are also many humans who are happy to offer great information. Since birding is one of the most popular outdoor activities, there is no shortage of people willing to share. Every city seems to have a birding club or group of interested birders. Most cities have camera clubs, too. Whatever your preference for acquiring knowledge, the goal is to find all you can about the five Ws, then go out and start learning through the lens.

Knowing where you want to go and learning all you can about that location will improve your photography. If you can find a place close to home with great birds, go back often and become the local photography expert. Help, give back, and promote the location with your photography and expertise. Knowing a place intimately will give you insight into what happens at different times of the year, and

you can capture a seasonal collection of images that will tell the story of the place.

I like to work with experts, and then I want to give back to them. I may offer to help with their project, write an article about their work, give them some photos to use, or give a presentation to a group in their name. I have helped refuges build blinds and have given them advice for improving

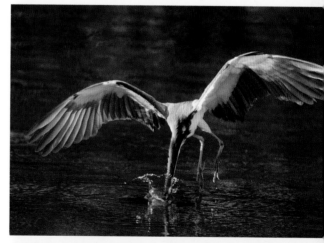

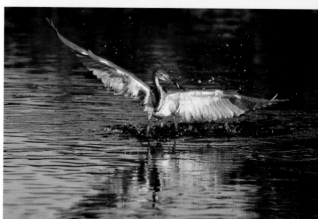

top—I tried to film California Quail in this field of flowers, to no avail. Fortunately, the flowers were amazing and the young ground squirrel was a great subject. **center**—Tricolored Heron fishing. Knowing these heron dip their heads down as they fly over the water allowed me to get this shot. In my research about Florida, I discovered about four different marshes to visit where the heron are cooperative. **bottom**—I shot this image right after the Tricolored Heron caught a fish.

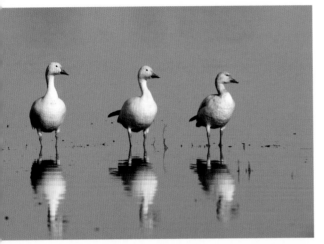

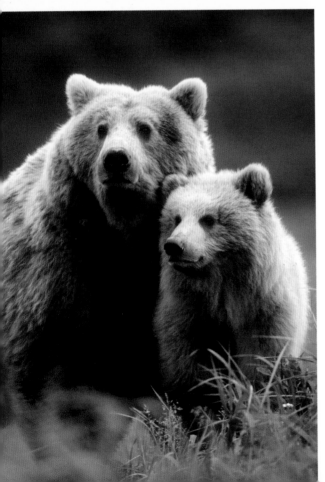

photographic opportunities for the public. Having a nice relationship with the staff might even open other doors. Giving back often helps build these relationships. Make friends; it makes photography that much more interesting.

Books, magazines, and other "old fashioned" print information are still valuable leaning tools, although many of the print magazines are going away. I like to read the birding magazines and field guides that still exist. Not only do I learn about birds and find ideas for getting a new shot, but I also study the types of images the publications use. This gives me knowledge about making better images and how to sell them. It's a win–win for both parties. I learn a lot, I make a few bucks selling my images, and they have beautiful photos to use.

How to Get Closer

Once you are in the field, behind the lens, remember to slow down and "get in the zone." In other words, get to the point at which all you are thinking about is how to make images. Let the minutia of everyday life slip away. It's a great way to spend time.

Move slowly and purposefully. This not only helps you focus on your images, but it helps to keep the subject calm and relaxed. If the bird flies away, your chance of photographing it is gone.

top—I was working with a biologist at a NWR in California and he told me about a great place to photograph waterfowl. It worked well. These Northern Shovelers did a nice wing flap before sunrise. **center**—The biologist was right. I got some wonderful waterfowl opportunities. Here is a group of three Snow Geese reflecting. Groups of three work nicely in compositions. **bottom**—Grizzly bear with cub. I was lucky these two didn't engage in fight or flight, and I got one of my favorite bear shots.

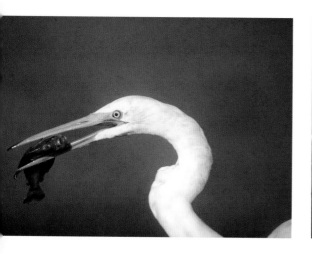

left—Great Egret with a piranha for breakfast. I got this head shot after stalking a cooperative subject that was busy feeding. **right**—This Andean Cock-of-the-Rock was displaying on its lek, and getting close wasn't an option, so cropping helped fill the frame.

Wildlife has a fight-or-flight distance; if you get too close to birds or other animals, they will either leave or attack. When it comes to Grizzly bears, you want flight because fight could be deadly to you. With birds, flight happens most of the time, but I have had a few experiences when the bird fought or attacked. Either way, your photos don't happen. So keep in mind the working distance between you and the bird, work slowly, and try not to get too excited.

While getting into position, you should be thinking about all things that will make the image beautiful. That means the behaviors, light, background, surroundings, weather, your proximity, composition, and the working distance. (Notice I didn't say anything about dialing in camera settings. You should have set your camera before you got out of the car.)

When approaching the bird, move fluidly, and don't let the camera gear and big lens on a tripod scare the subject. When on foot, get your gear set up on the tripod at the car, then start your approach. Take a few shots, check the histogram, and when you see the bird is okay with your presence, slowly move closer a few steps at a time. Continue until you are in the perfect position, then stay a while. Depending on the situation, I may approach in a crouch, as doing so makes me look less human.

One of the coolest things about today's high-quality DSLRs is the ability to crop without much loss of data. I don't try to get a head shot; I stay out of the fight or flight zone and shoot loose to allow space for the bird action to happen. I can shoot without cutting off a wing during a wing flap.

Shooting loose with digital is so much easier than it ever was with film. I do try to get closer for a head shot—I want that as well—but the action is where the great photos are.

7. ETHICS

No Photograph Is
Worth Harming the Subject

When our photography disturbs the birds while feeding, mating, or engaging in another behavior, we cause the birds stress. No photo is worth harming the subject. The more you learn about birds, the less intrusive you will be.

Of course, there is a fine line here. A man walking his dog scares birds away. Is it somehow more wrong for a photographer to scare them? Humans live in a world with birds and we often bother them, even when we don't realize it or intend to. Some of this is part of the bird's normal life.

When a beach is open to the public, whatever we do will disturb the birds. If we are feeding them, it changes their natural patterns, and at what point does our feeding them become their natural pattern? Is this better or worse for a bird? Isn't the material used to build the house we live in from a natural habitat somewhere? This is an interesting topic, and there are so many opinions about what constitutes disruption. Humans are always changing the habitat for our own good. When does it end?

I prefer being an environmental realist, one who understands that humans must share this planet with all other nature. Being aware and knowledgeable makes it easier to be an environmental realist. Lots of people do things that disrupt birds, without even realizing it. Maybe they pick up a baby bird because "it lost its mother," but it is learning to fly and waiting for mom to feed it. When photographing birds at a bird feeder, the birds will come and feed and

below—I watched several people walk by this Semipalmated Plover's nest. When they did, the bird got worked up and left the nest. The people didn't even know there was a nest. Once, I went over to photograph the nest, then left quickly so the bird would get back to its incubation duties. The chicks hatched without any issues. **right**—Was this photographer too close? The Long-Tailed Jaeger thought so. This is an example of fight or flight turning into fight.

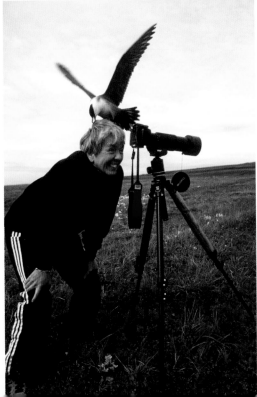

The Black Swiftlet nests in caves in Borneo. They are very tolerant of humans, even though their nests are harvested for bird nest soup. I just walked up to the nest in the dark and shot it with flash TTL –0 as the only light. My son held the flashlight so I could focus in the dark. Bird nest soup is a delicacy in some Asian cultures and brings in top dollar. The caves are protected by armed guards.

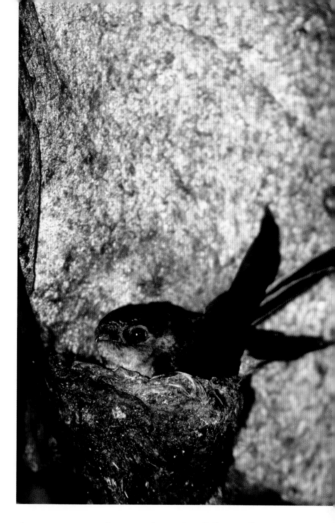

then, for no apparent reason, they will all fly off at once. This is a normal behavior for birds and one that helps keep them alive. When I am photographing birds feeding in a more wild, natural setting, their behavior is the same. They often fly off and then come back. Remember the fight or flight? If we cause them to fly off and they never come back, then we are being unethical. If we cause a bird to abandon eggs in a nest during nesting season, then we are causing an unnatural and unethical situation. My ethics rule is, "We must always put the birds' best interest in mind first, and then use common sense to capture them in-camera or in our memories." While photographing during the nesting season, it is best to watch from a distance. This allows you to get to know the "normal" behavior of the bird in that setting. When you set up your blind, you can move it closer every day and allow the bird to become accustomed to its presence. This setup and movement of the blind can be done at night when the birds can't see as well. I watch from a distance to be sure their behavior has not changed.

Sometimes you get lucky and it all works out with a cooperative subject; other times, you have to abandon your plans and just watch from a distance. At least you have

the memory and research, so it might work out the next time. You do not want to disturb the nesting. If the bird is allowing the blind or your presence, then you are lucky; they are allowing you into their world. Every bird is unique, has a different personality, and reacts slightly differently, so observe, be patient, and don't over-pursue your subject. My general rule of thumb for photographing birds nesting is to start photographing in earnest after the chicks have hatched. While building the nest and incubating eggs, birds are usually their most vulnerable and are apt to abandon the nest, so be ethical.

Once the chicks are born, the parents become focused on feeding them and are less likely to abandon the nest. However, the situation still merits caution. Having spent many days, weeks, months, and years watching and photographing birds, I believe that we photographers don't bother birds any more than the people who aren't aware of them do.

Some public places, like parks and refuges, have rules that say you can't get within so many feet of the animals. When there are millions of visitors coming each year, it makes sense. Go to Yellowstone National Park in the summer and you will see what I mean.

In some locations, whole areas and roads around a nest are closed to "protect" the birds. One example that comes to mind is a refuge

top—The Violet-Headed Hummingbird in Costa Rica had two young chicks in the nest. It was right by a road with lots of foot and vehicle traffic. Hummingbirds are very tolerant and not afraid of people. They know they can fly their way out of anything. **bottom**—The American Avocet chick just hatched, and its siblings came out shortly after. Once the chicks are born, the parents are less apt to abandon the nest.

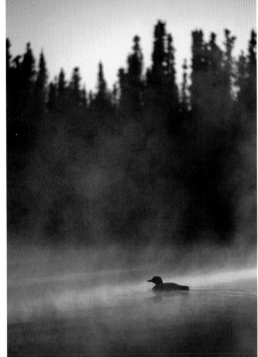

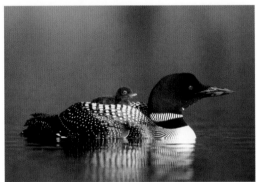

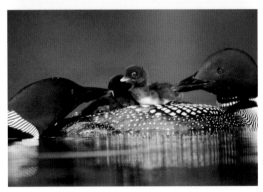

top left—One of my favorite rules and two of my favorite birders. This site was a clear-cut "wildlife refuge," if that isn't an oxymoron. **top right**—The Common Loon pair was cooperative, and I was able to work them over the course of three days. This morning gave me a glorious sunrise as the adult swam by. I really like the diagonal streak of light in front of the bird. **bottom left**—I took hundreds of photos of these cooperative Common Loons. I got portraits and, of course, my favorite baby-on-mom's-back shots. **bottom right**—I do love to get a tight shot, and this one works for me. Clipping parts can be awesome sometimes.

where a Bald Eagle pair has set up a nest along a dirt road that many people used to drive by while wildlife watching. The staff decided to close the stretch of road to the public. There is a canal between the trees, birds, and the cars, so the viewer can't get very close anyway. Of course, the refuge personnel drive the road daily, as do the muskrat hunters. This is overkill in my opinion. I have heard many stories where eagles have set up nests in and around people with no ill effect on the birds. It is their choice to set up in a populated area, and they are good with it. I believe that

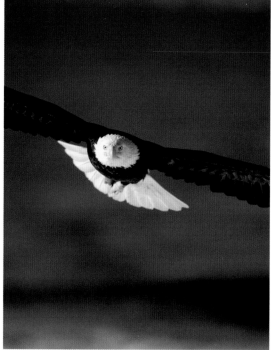

left—You can't be much more cooperative than a Common Potoo. These birds are so camouflaged, you could probably touch one before it was worried. Many people don't see them, as they resemble branches while they sleep during the day. **right**—Bald Eagle in flight. This one is so tight I clipped both wings. I like where it cropped though, it's tight enough that it works. I kept shooting as the bird flew toward me, and this was my favorite image of the series.

allowing the viewing would be a fantastic learning opportunity and would give people insight about the birds and inspire them to learn more about wildlife and protect it.

Cooperative Subjects, Continued

When in an area, I will drive around looking for cooperative subjects. Besides looking for a bird, I will look for areas where they are feeding, roosting, loafing, nesting, and living life. These are the places I will observe and get permission to set up a blind in.

If you have the time of a *National Geographic* photographer, you can find a great subject, live with them for months, and become part of their environment. Most of us don't have that kind of time, and so we find subjects that are accustomed to us. The

beauty of bird photography is you will find cooperative subjects near your home base or anywhere you happen to be.

Remember that wildlife, like humans, have four basic survival needs: food, water, shelter, and space. You can create cooperative subjects by setting up areas that address these needs. The most-used technique is to create a feeding station. Hummingbird feeders or backyard feeders are easy to set up. Water works, too. Some birders use bird calls to attract the subject, and this can be very effective.

Wildlife have their own personalities. Each species and individual has a unique way of interacting with the world. Some individuals of the same species are more tolerant than others, and more cooperative.

One story comes to mind. I have spent many hours, days, weeks, and months photographing Bald Eagles. I have been in close proximity to them and their nests, and they all behave differently.

One time I was watching a nest from a distance, scoping it out for how to set up a blind to get the shot. Before I was even in view of the nest, I was knocked over and rolled to the edge of the cliff. When I stopped rolling and my mind cleared, I realized an eagle had dived down and hit me with its talons. My head was throbbing and bleeding, and I was stunned. Once I got out of the area, I decided to set up my blind in the middle of the night under the cover of darkness. I didn't want to disturb the eagles any more. Just so you know, the nest was above a road in town. Over the course of my spending two days in the blind watching the eagles, people would come look at the nest. They got much closer than I had. The eagles never attacked them. So I guess even eagles have bad days. A week later, I heard that one of the eagles attacked someone walking along the road, and the person needed stitches to close the wound, so I felt lucky. These birds were cooperative one day, but not the next. I had some guilt for getting attacked, but then realized I just had some bad luck. After all, eagles are wild animals.

Ethology: The More You Know, the Better Your Photos

Wildlife are creatures of habit. There are a few behaviors birds do that are pretty consistent. We can learn these basics and use them to our advantage in creating exciting pictures. For example, when many birds drink, they will lean down and get water in their mouth, then tilt their head back to swallow it. Often, the water drops will be evident, and that adds action and drama to the image. Doves and pigeons can drink by keeping their beak in the water and sipping; they do not need to lean back.

This Cinnamon Teal was bathing. I shot loose enough to keep everything in the frame. There were water drops everywhere; after birds bathe, they flap their wings, and I was ready for that shot, too.

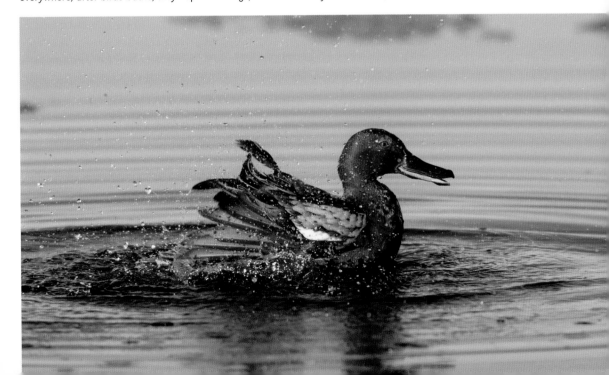

I always prefocus on the bird's eye area. I will then tweak the focus, compose, and press the shutter. If I am expecting a behavior, I try to anticipate where in the image the bird's eye will be. When birds wing flap, they stretch their body up, back, and flap. If you anticipate a wing flap, you will need to leave enough room for the bird's head to go up in the frame. Then you will need to achieve focus on the eye again. When birds are bathing, they dip their head and body under water then shake and wing flap in the water. Keeping the eye in focus is tough when the birds are moving.

I put the focus sensor on the bird's eye, or close to it, and manually adjust the focus as I'm shooting. It seems the focus sensor isn't always where the eye is. In those cases, I put the focus sensor on part of the bird in the same plane of focus as the eye (there is usually such a point on the bird's neck), then manually tweak the focus for the eye. Sometimes I will point the camera so a focus sensor hits the eye, then hold the focus lock button and recompose before I shoot. There are many ways to accomplish the same thing, so find what works best for you and your reflexes, and then practice.

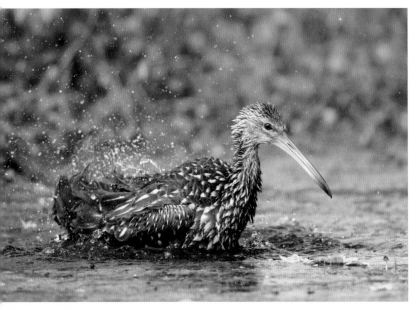

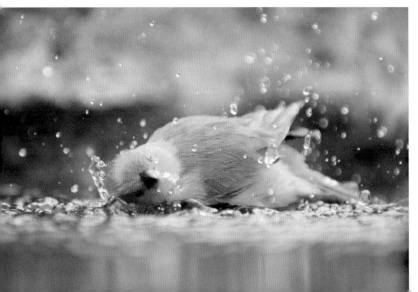

top—This Limkin was bathing and splashing lots of water. The action when birds bathe is fun, and water drops add another interesting element to the image. After the bath, birds will wing flap to get excess water off their feathers. Then, they often preen. **bottom**— This little Saffron Finch was bathing, and there was water splashing all around. Finches dip their bodies under water, and shake, rattle, and roll. Notice the background affects how the water drops show up. The lighter-colored water drops are more visible against dark background areas than light ones. When the drops are visible, it is called registering. We want contrast between rain, snow, and the background so it registers.

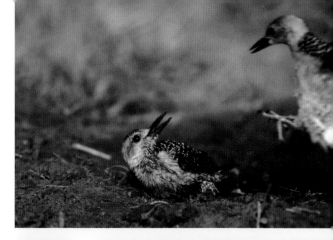

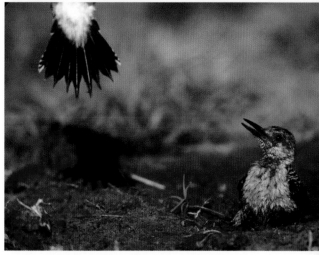

top—This Golden-fronted Woodpecker was bathing in the water, and then got out to take a dust bath, which turned into a mud bath. Another woody came by and startled the bather. The next shot shows the second photo of the series. I'm glad I was ready, and I'm thankful for the camera's continuous motor drive feature. **bottom**—In the next photo in the series, the aggressor continued to fly past the bather.

When birds are bathing, they dip their whole body underwater and often wing flap, so there is water splashing everywhere. After a bath, birds like to shake and preen. If you want to set up a water feature, keep these behaviors in mind. Smaller terrestrial birds like to perch after a bath to shake off and preen. Water birds like ducks will stay on the water to flap and shake the water off. The waterfowl may also go to a perch out of the water to preen.

If your bird does a behavior and you missed it, get ready because they often repeat behaviors. The more you know about behavior, the better you will be able to anticipate actions and behaviors so you can capture rare moments of peak action. For example, knowing that birds shake off and wing flap after bathing, you can anticipate what will happen when the bath ends. This is one of the most important aspects to capturing great action photos. It is also a good reason not to be too close. If you want tight portrait shots you want to be closer, but for behavior images, shoot loose so the water drops and wings flapping will help fill the frame. It is okay to leave some space around the birds. Editors love to be able to crop to fit their needs. There are some amazing action photos that are tight, though, and I love those too.

Make sure that there is enough contrast between the bird and background to allow the subject to stand out. Also, remember that the water drops won't show up as well against a light backdrop as they will against a dark backdrop. Finally, when you are photographing colorful birds, look for a background and color that will make them pop! Contrast between the subject and background is very helpful.

Another example of a predictive behavior is when birds are perched and decide it

is time to take flight. You will get tipped off because they often defecate just before taking flight. Anticipate the bird will lunge forward and slightly upward or downward so your focus is ready in the area of the frame where the bird will be. A larger raptor will leap off and down; a smaller bird can leap off and upward. Anticipate the behavior to get the shot, but also anticipate where the behavior will take the bird to get the focus and composition just right.

Of course, when you are waiting for a behavior, you will have preset your exposure and checked the histogram, so you will only need to focus on the bird.

The more you know about your subject and its behavior, the better you will be at anticipation. Even when you aren't photographing, watch and learn how birds behave. This can be done anywhere.

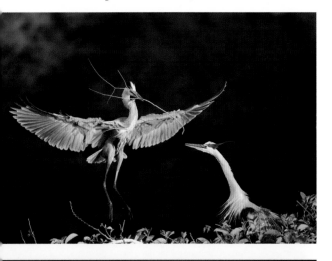

The Weather

Birds live outdoors; therefore, wind, precipitation, and storms affect them. We can use this information to our advantage.

Wind. Birds like to face into the wind. Their bodies are designed so that when the wind hits them in the face, their feathers stay in place. When they turn away from the wind, their feathers ruffle. They prefer to face the wind.

When a good-sized bird wants to leave the ground, it takes off into the wind. If the bird is taking flight from a higher perch where there is some room to descend, the wind isn't as important. Smaller birds can jump up more easily, and wind direction isn't as important because of their size. Perched birds prefer to face into the wind, but when they turn their heads and the feathers ruffle, it creates a neat image.

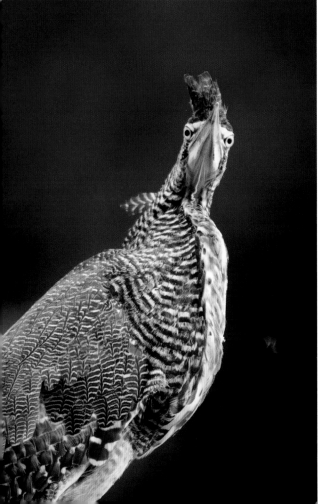

top—One Great Blue Heron was sitting on the nest and another was bringing sticks back every so often. When I saw the nest-building behavior, I decided to wait in position, hoping it would happen again. It did, and I was ready. **bottom**—This Fasciated Tiger-Heron perched facing the wind. When it turned to look at me, its feathers blew. This created an interesting pose. A mosquito added to the action.

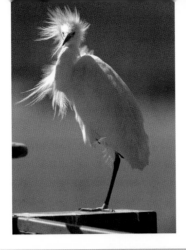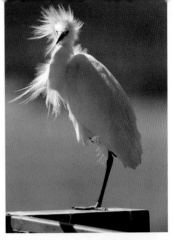

left and right—Snowy Egret with feather plumes ruffled in the wind. Notice the pipe in the bottom left. I removed it in Photoshop. **below**—Great Egret landing. These larger birds like to land with the wind in their face; it makes it much easier for them. Pilots use this technique too and learned it from the birds.

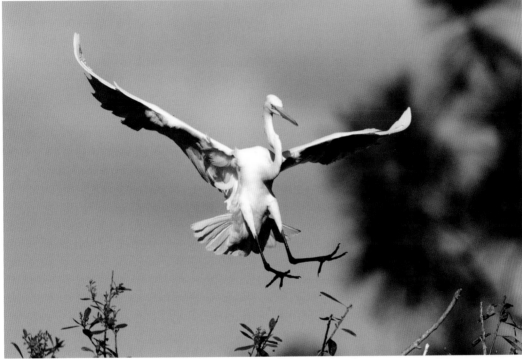

Whether you are setting up your own feeding station or photographing out in the field, pay attention to the weather and how it affects the birds. When the wind and sun are behind us, the birds will land facing us. This is what we want. When the sun is behind us and the wind is blowing in our faces, the birds will land facing away from us. When you get to know places, tune in to these things. If you are going to a new spot, check in with some locals to get an idea about the wind and weather patterns and how they might affect the birds.

Precipitation. Precipitation affects bird behavior, too. Snow and frigid temperatures can be stressful for birds, but their feathers are amazing insulators. If they get ample food to fuel the higher metabolism it takes to survive, the cold is usually no problem. Birds fluff their feathers while perching to

top—Bald Eagle in snow. The flakes registered well due to the dark background. The eagle had just landed, stirring up even more snow. **bottom**—I knew where the American Coot was nesting, so when this rainbow appeared, I headed there. I captured the bird and rainbow with my medium telephoto lens. I was in my car, which kept me dry and the bird on the nest.

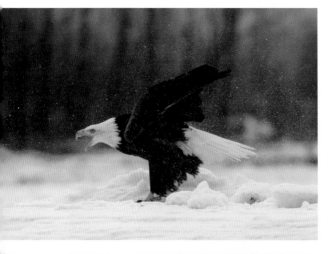

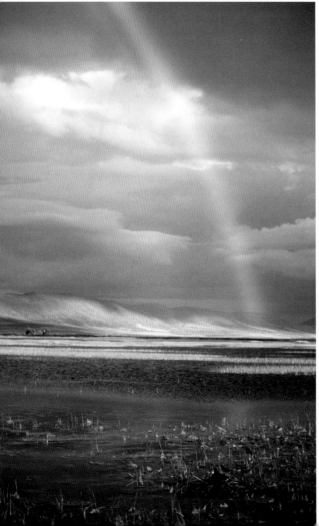

stay warm, and this look can be photogenic. I love shooting in the snow, especially when it is falling. Make sure the background is darker so the snowflakes will register.

Raindrops and wet birds make for unique images. When it is raining, birds shake and wing flap to remove excess water from their feathers. This is a good opportunity to capture action photos. I try to stay in my car, in a dry blind, or under cover of some sort for my comfort and the camera's safety. Rain is tough on camera gear, so be prepared to keep your equipment dry. My friend's high-tech professional camera's electronics died when we were caught in a downpour while photographing in Costa Rica. I was thankful I had my camera's rain cover, and he was glad he had a backup camera.

Rainbows always present a great photo op. I've seen fogbows, and they help make great bird scenics. There is an urban legend that snowbows exist. If the snow is wet enough, it should be possible—but then, I'm still hoping to photograph Bigfoot.

Storms. Photography is all about light, and storms can create dramatic light. Be ready, pay attention to the weather, and always ask yourself, "How can I turn that into a unique beautiful shot?" Sometimes you just have to photograph the beauty of the surroundings when no bird is around. I am happy to create a beautiful image without birds, and that makes for less stress on me. As a photonaturalist, I enjoy nature all around me.

Plumage

Look closely at your subjects and their feathers. How do they look? Sometimes they get dirty and appear off-colored. Not many calendar companies will buy those shots.

Some birds look different throughout their lifespan and even seasonally. If you look in the birding guides, you will see pictures showing these differences in plumage. Some birds take two to four years to reach maturity and sport adult plumage. A juvenile gull looks different than an adult gull; this is also true of eagles and many other birds. Some adult birds look different in the breeding season, then molt to a less colorful winter plumage. Many grouse and shorebirds transform into much more ornamented birds during spring, which is the time of year they will display on their breeding grounds.

Birds are beautiful in their own right, even ones we don't pay much attention to. The gorgeous ones are a no-brainer as subjects, but even they molt. When a bird molts, it replaces worn-out feathers. The process is vital to survival. Raptors will regrow/replace a flight feather or two at a time. So you might see a Bald Eagle flying around with a feather missing from its wings. These flight feathers are replaced constantly, and it might affect the look of the bird. To me, a photo showing a missing feather tells a story, but the editor at the calendar company may perceive the missing feather as a flaw and opt not to run the shot.

Waterfowl molt all their flight feathers at once. The molting usually occurs after the

top—This female Northern Cardinal does not have the striking red feathers that we see on a male with breeding plumage. **bottom**—This male Toucan Barbet is a real beauty. Adult males are much more colorful than females and immature birds.

nesting season, in late summer, and the birds are flightless at this time.

Even a colorful adult male waterfowl will look drab during the molt. They appear partially colored until gradually, the full breeding plumage returns. If you want to photograph a colorful Mallard male, don't look for him in August. But if you are telling the story of molting, that's precisely when you'll need to get the shot.

Breeding Season: The Nesting Cycle

Nesting is one of the most unique times in the bird world, and it's a great opportunity to capture exciting images. This is my favorite shooting time of the year, and it's the topic of my first book, *Baby Birds*. The nesting cycle starts with courtship and breeding, then nesting and raising the young. I love spending time with courting birds, and the courtship features some amazing rituals. From the rushing Western Grebes, to Grouse on their leks dancing, to singing songbirds, action and interaction make for my favorite images, and the nesting cycle presents many of these wonderful opportunities.

In North America, spring is the most common time for attracting a mate. Waterfowl court in the fall, however. Nesting can start in February with some of the early nesters, like Great Horned Owls and Canada Geese, and lasts until late summer with some water birds, like Grebes. Of course, how far north or south you are also determines the timing of nesting.

When photographing courtship behaviors, pay attention to patterns. Birds

left—Western Meadowlark singing. Courtship includes birdsong, which makes nice action opportunities. Birds are creatures of habit and will often sing from the same perch or perches over and over. Once you have identified these spots, be patient and wait for the bird to come back. **right**—There were three eggs in this California Towhee nest, and as soon as one hatched, I took a photo. I was watching the nest for weeks as the adults built it and incubated the eggs. It was outside of my office window, so I opened the window, leaned out, and got the shot.

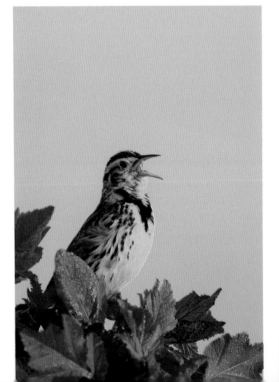
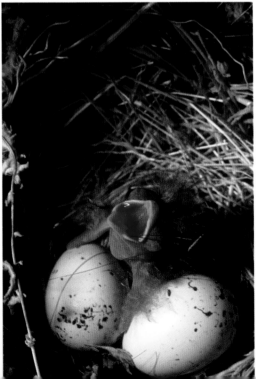

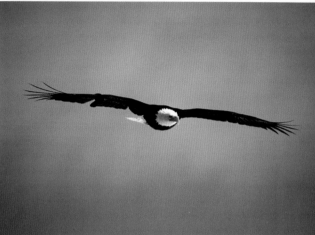

top—The male Northern Cardinal, like most male birds, is more colorful than the female. **right**—Bald Eagles molt one feather at a time. This eagle has a feather missing from its wing. You could use your computer skills to add a feather.

sing from the same perches over and over again to attract a mate. It's a good idea to set up a blind by one of these perches. When birds are building a nest, laying eggs, and incubating, they are their most vulnerable. If you put too much pressure on the birds at these times, they could abandon the nest, so keep a distance. This is a good time to set up a blind at a distance and slowly move it closer over time. If you sense any disturbance, abandon your photo plans. If we scare a bird away, we lose our photo opportunities, but more importantly, we disrupt the birds during breeding season.

Shooting a nest during incubation is boring. The birds sit motionless on the eggs for days. If you wait long enough, you can get the parents changing positions on the eggs, when one adult gives the other a break—unless it is a hummingbird. In that case, the females do all the nesting work!

Some nesting birds are quite tolerant. Cavity-nesting birds are a good example. Maybe they feel safe when they are nesting inside of a protective tree or cavity. Photography is mostly done outside the nest, but I have seen some interesting shots made inside the cavity. You can get a nest box and insert a viewing camera, which becomes part of the nest hole. The birds won't realize they are being watched and will not be disturbed, because it is all done remotely. This type of photography can result in unique views.

When photographing the nest, I usually get a few shots and then go back in a week or so and try to be in position for hatching day. Once the birds are feeding their young, they are a bit more tolerant and accepting of a blind. Of course, this is the most critical time for them not to be disturbed. They need to raise a family. I like to photograph at this time, as there is a great deal of action while the young and the parents interact.

Some photographers choose not to photograph at this fragile time of year. It is my personal favorite time, and I always put the birds' welfare first. When I am photographing an entire nesting cycle, the

birds grow accustomed to my blind and are highly cooperative. Remember those Burrowing Owls? No blind was needed. I would sit for hours at my 500mm minimum focusing distance. That is tolerance.

My ethics won't allow me to cut or trim vegetation near the nest or make changes to the area around the nest. I simply exist in my blind at a safe distance and create great photos. Most nests don't make great photo subjects, so I keep looking for one that might. When everything comes together, you can get award-winning images.

Calls and Recordings

Many birders and photographers use a call or recording to attract birds. You can play bird calls on your smartphone or use high-tech recording/amplifying devices. Some people will record a male singing, then replay it to get the bird into view.

Birds are territorial and will come to investigate a call of their own species. Males will want to chase a rival male away. Some

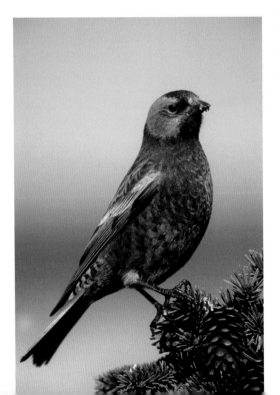

birds will come investigate an owl call, as they will want to alert other birds that a predator is nearby.

The downside of using calls is that you are disturbing the bird's natural behaviors at the moment. If you are in a popular birding area, there may be many people trying to lure a specific bird into view. In areas where dozens of birders or bird photographers are using calls, birds may expend excessive energy. Some popular places ban using recordings due to the potential to disturb a bird when many people are playing calls.

Think about the birds' best interest, and make your own decisions. Also, keep in mind other people in the area. If you are in a popular spot where other folks are enjoying the birds, you don't want to ruin their experience. I prefer to use calls sparingly and only in areas where I am alone. It is important to be a good steward and help give bird photographers a good name.

I have been in the field with expert biologists who use bird calls for their field work. Spotted Owls are called in and fed so the biologist can follow the bird back to its nest. This technique helps them know where the nests are and how many birds are producing young of the year. I was able to get some great shots with a biologist who used an owl call to get the owl within range of my 80–200mm lens. Working with an expert helped me get the shot, and I gave him fantastic photos to use in his work for presenting and teaching about the birds.

Songbirds like this Gray-Crowned Rosy-Finch are attracted by bird calls and bird seed. Notice the nice cone-covered spruce perch at the feeding station.

Make It Happen

Designing feeding stations, water holes, and bird habitat will draw cooperative subjects and give you plenty of opportunities to learn about bird behavior. Creating a photogenic area with perches and backgrounds will be the icing on the cake for crafting beautiful photos. In this chapter, I will touch on the essentials for creating effective setups. To learn more about the topic, check out the eBook *The Guide to Songbird Set-Up Photography* by Alan Murphy.

top right—The classic bird-on-a-perch portrait. This male Painted Bunting came in for water. When building your own setup, keep in mind that the perch should be placed slightly above the water. **bottom right**—This was an easy setup at a popular trail where the Florida Scrub Jay is used to getting food. This is Florida's only endemic (found only in Florida) bird, and it is endangered. I put a branch down with a nice knob high point, then got into the prone position with my 500mm lens. I put out some peanuts, and the birds arrived in minutes. Notice the distant background with a hint of blue sky. **below**—This is a basic setup with cracked corn in the tray feeder. There are a couple of examples of the perches nearby. The branch on the ground over the food is the basic setup used for the Florida Scrub Jay. The perch above in the tripod handle will work for a thinner perch. The big oak in the Christmas tree stand would be a good perch for woodpeckers and such.

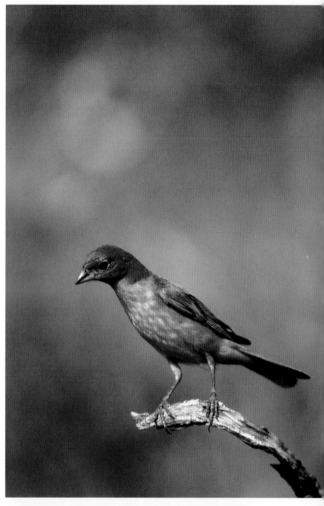

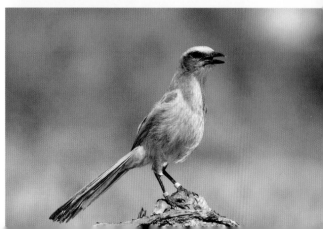

Feeding Stations

The feeding station should be well stocked daily so that birds will learn that food is always there. For best results, place the feeding station in an area that has good light and a nice background, one that is far enough away to render an out-of-focus wash of color. I like green leaves in the background. You can also put your own background in place. Consider colorful flowers or even a colorful cloth like a studio photographer might use. I prefer one that has colors commonly found in nature. This is often how photographers produce the garden bird photos (often called backyard bird photographs) that grace the pages of calendars and birding magazines.

Learn what birds in your area like to eat and how they like to feed. Goldfinches like sunflower and thistle seeds in a hanging feeder. Quail enjoy feeding on the ground and will come in for cracked corn (a cheaper food source that you can purchase at a livestock feed store). Fresh fruit is a favorite of Orioles and Mockingbirds, and placing a half orange on a platform can work. Suet is a good option for Woodpeckers. The list goes on and on. Find out what birds live in your area, then select feed that will attract the ones you want to photograph.

top—Fresh fruit, like oranges, is a great attractor for fruit lovers like Orioles, and it was a draw for this Northern Mockingbird. Notice the background wasn't quite far enough away to become a blur. **bottom**—I used a distant vegetation background and added a potted Columbine for the perch. The Lesser Goldfinch landed before he went to the black sunflower seeds I had put out.

Once you have attracted the birds to the feeding station, put a beautiful perch above the food. The bird will land there before coming down to feed. Landing above the food source allows birds to observe the area before feeding. This gives them a chance to spot a risk. When eating, birds are more vulnerable to predators because their focus is on eating and their heads are down. When you are attracting more than one bird, which is often the case in backyard feeding stations, note they will feel safer in a group. The old adage "safety in numbers" applies.

If you are attracting non-ground-feeding birds, it is helpful to place the perch and

top right—This California Quail was drawn to the cracked corn on the ground. I had an oak branch for him to land on. Pay attention to the "white wash" that birds leave behind. You will need to wash or change your perches so this doesn't detract from your image. **below**—Here is one of my Lesser Goldfinch setups—a black sunflower seed feeder in a field of wildflowers. Once the birds started coming in, I added different perches for them to land on. **bottom right**—Here is one perch of a local oak tree branch, which matches the local flora. You can see I added different perches and used different lenses for more unique Goldfinch images.

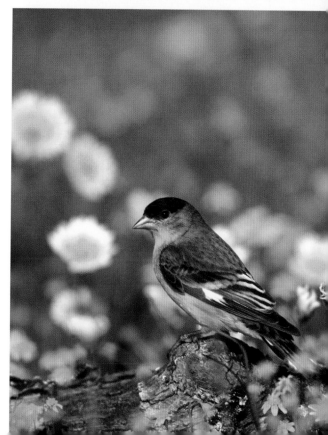

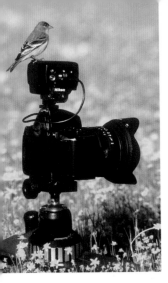

left—Here, the perch is my remote trigger on camera with a wide angle lens. I wanted to get a unique look that showed the expanse of flowers using my wide angle. I was in my blind with my 500mm lens and had the wide angle remote up close to a nice view and controlled both cameras from the comfort of my blind. **right**—A wide angle version of the Lesser Goldfinches. I wanted to create a bird scenic. I'll keep working on perfecting this technique.

feeder at eye level so you can photograph from a comfortable chair. I raise the feeder to avoid being prone. Being comfortable makes it easier to work.

Hummingbirds: The Winged Jewels

Only the Americas have hummingbirds ("hummers"). Hummers will readily come to feeders once they discover them. The feeder becomes an easy photo setup. Fill a hummingbird feeder with a nectar of 4 parts water to 1 part sugar, and no added color. If you live east of the Rocky Mountains, you only have one species of hummingbird—the Ruby-Throated. If you are lucky enough to live in the West or Southwest, there are many more species to attract. If you really want hummers, though, a trip to Central or South America is for you.

Once the birds are coming to your setups, it is time to make them go exactly where you want for the pictures. Find a perch or flower you want in the image with a bird on it. When the hummingbirds become used to the feeder, replace it with a beautiful flower and add some sugar water to the flower. You can use potted plants (they look fresher for longer) and use an eyedropper to apply the sugar water right on the flower so the hummer will go there to drink. Another idea is to cut a beautiful branch with flowers, put it in water to keep it looking fresh, and use it in place of the feeder. The hummer will come in looking for the feeder but will find the flower instead, and you will be ready to get the photos. Pay attention to the background. Make sure it looks nice and clean in the final image. Make sure the flower you pick looks good too. Putting the sugar water exactly where you want the bird to go creates the perfect shot.

There are many ways to set up your lighting. Most hummingbirds are photographed with flash. The photos you

see where every feather is sharp as a tack and properly lit are made with a multiple flash setup (often four flashes). If an extreme multi-flash setup isn't for you, there are other ways to make great shots.

My favorite technique is to use a very fast shutter speed with only one flash. This is easy and creates wonderful images. Today's DSLRs work beautifully at high ISOs, and this allows us to crank up the shutter speed and use flash. I use ISO 2000 with a shutter speed of $^1/_{3200}$ and a wide-open aperture. You can bracket your exposures and see how much wing blur you prefer. I like a bit of wing blur, as it shows the true nature of these fast little guys.

To see the color of the gorget (iridescent throat area), you need light that hits the area just right. To achieve this goal, I often position a second flash to the side.

To show the colorful feathers and ensure the birds are in sharp focus, most

left—(top) Green-crowned Brilliant on Heliconia plant. In Costa Rica, the hummingbirds were coming to the feeders nicely. I put some sugar water in the plant, and it didn't take long for them to find it. (center) The hummer raised its wings and I got another shot of him. The background vegetation was in the sun and the bird in the shade. I used one flash at TTL -2²/₃ for fill. (bottom) Here is the same image with no flash. I bracketed my exposures. Notice how much more iridescence you get with the flash. **right**—This Rufous-Tailed Hummingbird is in flight. I photograph these birds as they go in and out of the feeder and catch them just as they go back far enough that the feeder disappears. No flash was used, but the color showed up well.

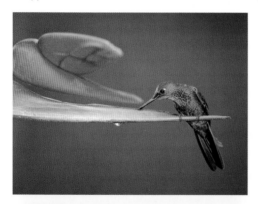

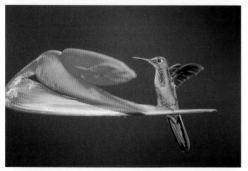

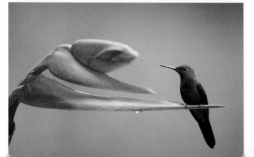

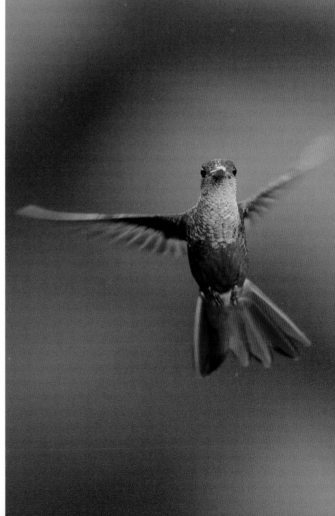

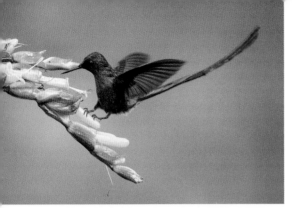

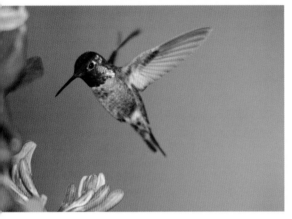

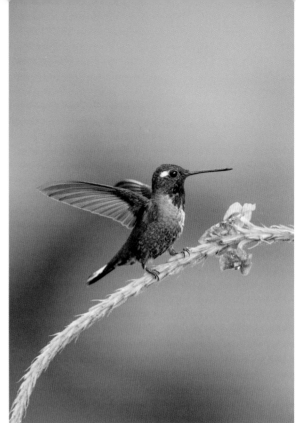

top left—Flash wasn't allowed when photographing this Violet-Tailed Sylph at this lodge in Ecuador, but the bird's tail color showed up well. Flash would have helped light it more evenly. **bottom left**—One flash hit the male Anna's Hummingbird to render some gorget color. There is not as much depth of field as there is in the shots made with multiple flashes. I like this look; it seems more like what a hummingbird looks like—there's lots of motion. **right**—This Purple-Bibbed Whitetip came to a flower I'd added sugar water to. No flash; the image was made on an overcast day.

hummingbird photographers use multiple flashes. In truth, it is possible to effectively capture the bird's color using one or two flashes, and it is much easier than having to sync four or more flashes. It's important to ensure the iridescent feathers are well lighted; otherwise, they will appear black in the photo.

If your camera and flash allow you to use high-speed flash sync, you can get good results with just one flash. (Canon calls the feature High Speed Sync, Nikon calls it Auto FP High-Speed Sync.) To set my Nikon, I go to custom settings, flash, and

select the $^1/_{250}$ second (Auto FP) setting. This enables the flash to fire at any shutter speed.

Here is the one-flash hummer setup starting point: With a shutter speed of $^1/_{2000}$ second, ISO 1000, aperture of f/11, the flash on a bracket or the hot shoe plugged into a battery pack, a long lens and a tripod, you are ready to go. The settings should register the background properly exposed in the sun. The bird/flower will be properly lighted by the flash. The flash should be set to fire at any shutter speed, and the TTL setting should be somewhere between 0

and −3 depending on your camera and the look you like. The lens you select is basically the one you have or want to use. I like my 500mm lens, with an extension tube, here, so I can get close enough to fill the frame and get a nice blurred background, but you can always shoot looser and crop later depending on your needs. Again, bracket your exposures to find your favorite combination.

I often put the feeder in a shady location with a distant sunny green background of vegetation, lawn, or cloth. I wait in the shade with the feeder and am comfortable in my chair, sipping my favorite beverage. I told you bird photography is hard work!

Once the hummers are coming regularly to the feeder, I put a flower in its place. I add as many drops of sugar water as the flower will hold without showing up in my image. I don't want to get up to reload the sugar water every time the bird visits the feeder. You do have to keep the flower filled with food, or the birds will lose interest.

Now, it is time to shoot. If you are using an extension tube that doesn't autofocus fast enough, make sure the plane of focus is on the flower; that way, you can minimize your focus adjustments. During my most recent trip to Ecuador, I went with no extension tubes and just my autofocus, using the Nikon D5, then cropped slightly later. This makes focusing easier and gives room for the birds to do something cool without my clipping off a wing or tail. I used flash and no flash about 50 percent of the time.

Once you have this technique down, try adding a second flash synced to the first and off to the side for even better lighting of the gorget and colorful feathers. A second flash will increase the number of well-lighted shots. Be creative, too. Maybe add a colored or warming filter or choose a slower shutter for more blur. If you get a second flash that will fire wirelessly, there will be less cords and things to set up. When you use a second flash, dial it back a full stop from the main flash (e.g., if the main flash is at TTL 0, the second flash should be at TTL −1).

If you want to use more flashes, you will have your main flash on camera, one flash off to the side, one flash on the background, one for backlight. Multi-flash hummer photographers set the flashes in manual mode, not TTL, and maybe at $1/16$ power. They can set the aperture at f/16, and all the light will come from the flashes, with none from natural light.

The easiest hummingbird setup is done in full sunshine. Put the feeder in the sun and make sure the background is in full sun, too. Photograph your subject with and without flash; both approaches will produce nice images. Set the shutter speed as fast as you want. Start at $1/2000$ and bracket from there. Once the birds are coming to a feeder, switch it out with the potted plant or flower in water.

When you want perched hummingbirds, add a tiny perch a few feet above the feeder. They will often perch in between feedings. Sometimes they will guard "their" feeder from other hummers and will perch to be on

the lookout. Make sure this setup isn't too close to other trees or perches.

Water Features

Birds can be easily attracted to an area with a water feature, especially in dry areas. It doesn't take much water once the birds know there is a reliable source. They need to drink, but they also need to bathe to keep their feathers in prime shape. There are some important things to know about the water that birds like to use:

• The setup should have a sloped edge for easy access. The water should be shallow to allow birds to stand on the bottom of the water feature while bathing.

• Place your water feature near bushes so the birds can quickly get away from predators. Your water feature will attract birds, but it may also attract their predators.

• Have a nice perch or two set up above the water. Birds like to land and assess their surroundings before they go down to the water. They also like to preen on a perch after a good splash and bath.

• Birds are attracted by the sound of water dripping or trickling. For a permanent area in your yard, a garden hose or dripper

left—A Cassin's Finch came to my water hole while I was camping. I included a pine cone for a perch. **right**—This Mourning Dove came to the water feature on the ground. The water feature was just a small scrape in the ground lined with plastic and hidden by the surrounding dirt. When shooting, I like to get as low as possible for a better background and a reflection.

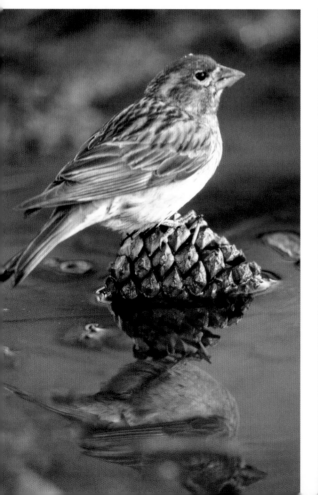
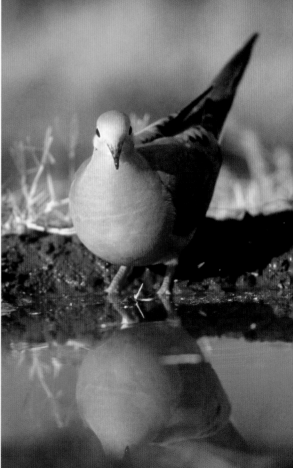

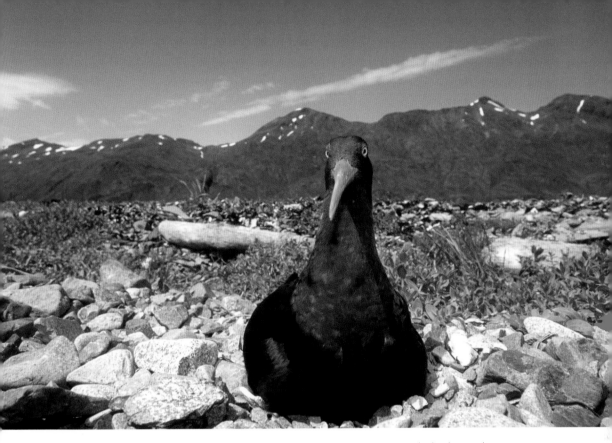

Here is another version of the Black Oystercatcher with the nice Alaskan mountains in the background.

is perfect to keep a trickle going. For the traveling water hole, bring a small piece of plastic or pond liner and hang a milk jug or water jug over it, dripping slowly.

- Provide a consistent supply of clean water.
- If you are photographing the bird in the water or at the water's edge, make sure the background is far enough away to blur. Shoot as low as you can for the best background look. You could even raise the water feature off the ground a couple of feet to give a more distant background. Consider setting it up for reflections.

Remember, all these ideas can be applied anywhere you are; it doesn't have to be in your backyard.

In areas where water freezes in the winter, keeping a water feature open and thawed is valuable because it might be the only available water for miles. Birds can't drink solid water!

Water is great because it attracts even birds that wouldn't normally come to a feeder. In wet climates, water isn't as good of an attractor, because there is so much other available water around. In these cases, food is a better draw.

If you want to make bird photographs with no water showing, put the perches just above the water. The birds will perch before going down to the water. If you want a bathing shot, make the water hole on the ground and camouflage it with dirt. If the

water feature is large relative to the bird, then the background may be water or, if it is far enough away from your subject, it may appear as a wash of color.

The ideal blind to use with a homemade in-the-ground water feature is a pit blind, as you will be underground with the lens at ground level. This is the perfect angle from which to capture the bird in the water, and it ensures that the background will be far away. If the water hole is large enough, you might get nothing but water, bird, and reflection in your image. I am working on putting a pit blind in my yard.

Remote Setups

Using a remote triggering device will allow you to work from beyond a bird's fight-or-flight distance and still get a great shot. There are two basic remote trigger types on the market. When using the first type, you must push a button to trip the shutter. The second type of remote is automatically triggered when the bird moves through the scene. The latter type can come in handy if you know the flight patterns of the bird you wish to photograph.

I use a remote that I control. I place my camera near a bird and then fire from outside the bird's fight-or-flight distance as I'm watching. That way, I am able to capture the photograph when the bird is in the perfect position. The bird gets used to the presence of a camera before it gets used to a person, so working remotely will help the bird feel more relaxed. If you plan to photograph particularly timid subjects, you may need to leave your remote setup in place for days or weeks before the birds feel safe.

A view of my old film camera's remote trigger. They are basically the same today and consist of a wireless remote controller you hold in your hand and a transmitter that attaches to your camera.

You can get an inexpensive wireless infrared remote control that will fire your camera as long as you are within its range in the line of sight. One from Nikon will fire the camera up to 16 feet away and costs roughly $20.00. It also doubles as a cable release, as it allows you to fire your camera without touching it. This is helpful for long exposures and when you are trying to eliminate all camera movement for maximum sharpness. Unfortunately, 16 feet isn't very far away from a wary bird, so these units are nothing more than a wireless cable release to me.

I am also a fan of using my camera brand's accessories, and this is another reason to go with Canon or Nikon. Both companies offer myriad accessories; you can easily find what you need to solve any photographic problem.

A wireless radio-controlled remote can cost about $200.00 and will fire 50 yards or so depending on the brand and model you get. This type is more useful for wildlife photographers, and it's the one I have. You have to release the shutter, like taking the picture, but you do so from a distance. I often stay hidden and watch the bird with my binoculars, then trip the shutter at the perfect time. This remote will allow you to fire multiple cameras too, if you really need coverage. A radio trigger does not require you to be within the line of sight.

There are apps on the market that will also allow you to wirelessly trigger your camera. This is a rapidly changing technology. For more information about what's available, search the Internet for materials on apps made for your particular brand of camera.

Photo traps are another option. These systems emit an infrared beam, and when an animal moves through the beam, it triggers the camera's shutter release. These are the top-of-the-line capture systems and cost about $500.00. You will want to set a photo trap up in an area that the bird will fly through consistently. A barn owl flying through a barn window to its nest would be a good candidate. In this situation, you would position the system so that its infrared beam would go across the window. Every time the owl flew through the window, the shutter would be triggered. If you are interested in using a photo trap, you may want to consider purchasing a trail camera. Some even come with waterproof housings and all the fixings so you can leave the camera outdoors for weeks.

Today, there are devices available that allow you to see a live view of your scene on your laptop. One is tethered with a cord, and the other is wireless. For me, the wireless model is more useful. Nikon offers ControlMyNikon, software that allows you to see live view on a computer with a tether. Do some research to see what is available for your camera gear. With new cameras and products coming out all of the time, remote control and remote viewing options are always changing.

9. COMPUTER TIME IS A MUST

To me, getting a proper exposure in-camera is what photography is all about. Still, there is no denying that, these days, computers are an important part of the journey from capture to final product.

Workflow

After the shoot, I upload my images onto my MacBook Pro, import them into Lightroom, and save them to an external hard drive. I also back up my images on a second hard drive. I like to use the smaller portable hard drives with the largest storage capacity available. The Cloud is another great option for archiving images.

Traveling with a laptop and a couple of portable hard drives is easy and lightweight, which is important if you fly. I use a 15-inch MacBook Pro to do all my computer work. I like the ease, convenience, quality, and size it offers. I often travel to remote locations with no Internet, but the hard drives are always accessible.

I use a fast external card reader to upload my images to my laptop during a mid-day break or in the evening. Once the images are safely backed up on the second hard drive, I format the memory card in-camera. Then I have an empty card ready to refill with bird beauty. I use 64 and 256GB CompactFlash cards, which allow me to shoot nonstop for hours. I have been shooting some video as well, and the larger memory capacity helps with that, too.

There are many ways to catalog and edit your photographs. I started using Lightroom and have come to really enjoy it. My recommendation is to find a good system and stick with it so you become very skilled at using it. You might select a program that your closest photo friends use; that way, you can all share your knowledge.

Once I have imported my images into Lightroom, I begin to edit. I look for great

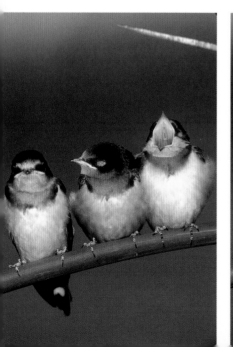

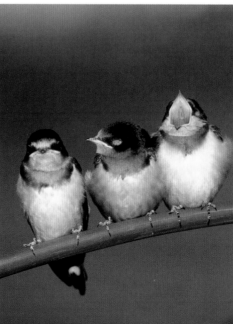

left—These Barn Swallow fledglings were cute and cooperative. I wanted to allow a lot of room above the birds, but I couldn't get an angle to keep the bulrush at the top right from showing up. **right**—Photoshop allowed for an easy fix. I like to use the Clone Stamp tool to remove spots and little things like the bulrush.

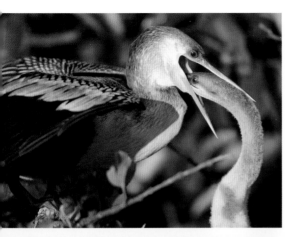 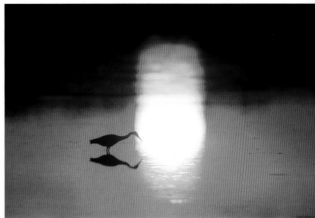

top left—Anhinga feeding its young. What a cool behavior shot! The foreground would look better with the branches removed. Maybe someday. **top right**—Tricolored Heron at sunset. The bird was heading toward the bright sun reflection, and I waited for the right moment to capture the shot. Traveling with a MacBook Pro with external hard drives is easy. This photo was cropped in Adobe Lightroom. **bottom**—It is easy to search the Lightroom library and find what you are looking for if you have keyworded your images. This Great Egret was captured preening. The tongue made it funny. Sometimes you just get lucky.

shots and mark them using Lightroom's star rating system. I immediately delete any images that are out of focus, poorly exposed, or not well composed. I ensure that the keepers are keyworded with the location, date, and subject, and I have the program set up to automatically include my contact information in the metadata.

Once the editing is done, I add keywords for specific behaviors, species, and type of bird. I add tags to indicate whether the image features a baby or chick, a mated pair, etc. This helps me to locate files with such subjects, should I need to access them.

The downfall to my system is that I have filled five external hard drives over the years, and when it is time to retrieve a photo, I need to find the correct hard drive. To facilitate this, I label my hard drives with dates and general shoot information. I also

keep them arranged in chronological order.

Fortunately, Lightroom makes it easy to find a specific photo. In Lightroom, I create a folder for the year, and in that folder I have images labeled with the location, month, and day (e.g., Cuba June 23). No matter your method, find and implement a system that works for you. It's too hard to keep everything organized in your mind when you have hundreds or thousands of images.

Optimizing Your Images

The ability to optimize your images after capture is one of the greatest benefits of digital photography. However, too much editing isn't a good thing. It's best to keep it to a minimum. The goal is to get a perfect, or near perfect, image in capture.

While editing in Lightroom, I check the color temperature (white balance) and make sure the exposure is spot on. If the image calls for it, I may open up (lighten) some dark areas or remove a small branch or obtrusive thing.

I will then crop as necessary to enhance the composition. It seems we are always trying to get closer to wildlife, and cropping is a wonderful means to accomplish that goal. As I've said, I am starting to shoot looser. I can stay farther back and give more room for the action to take place in the frame. If I want a tight portrait, I can crop the image in postproduction. For me, cropping in Lightroom is one of the best breakthroughs in the world of bird photography.

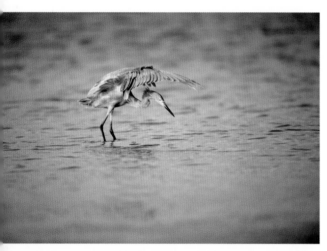

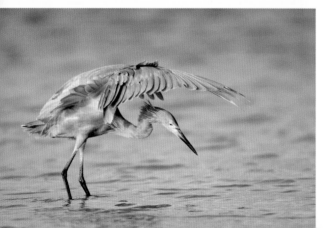

top—Reddish Egrets have an exciting hunting technique. I was a little far and wanted to be closer, but knew I could crop later. It is easier to get the bird in the frame and in focus from farther away. **bottom**—Here is the photograph after I cropped it in Lightroom.

Become the Expert in Your Backyard

Birds are everywhere, and that is one of the coolest things about photographing our feathered friends. I recommend starting close to home, and then branching out. Make your mistakes close to home (for me, within a three hours' drive) and learn from them. Hone your craft before you venture too far. I am lucky to have a number of National Wildlife Refuges, the Pacific Ocean, and mountains in my "backyard." I enjoy shooting in these locations and have come to know them intimately. My collection of "backyard" images is extensive, and I am always adding to it. I want to be the specialist, the go-to guy, if someone needs an image from Northern California.

Traveling beyond my backyard is also my passion and has allowed me to expand my collection of nature photos, especially birds and wildlife. A diversity of habitats presents different bird species to photograph. What follows is a brief listing of some of my favorite places to travel to photograph birds. This list is by no means exhaustive, because everyone's backyard can be the best place to go, depending on the species of bird you want to shoot. These areas are great for finding cooperative birds, and many locations offer other compelling photo subjects, too. I shoot those subjects with the same passion and love as I do for the birds.

Beyond the Backyard

Any location at which the birds have become accustomed to humans can be a good place to shoot. Look for parks,

10. HOT SPOTS

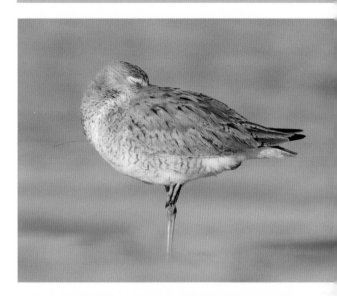

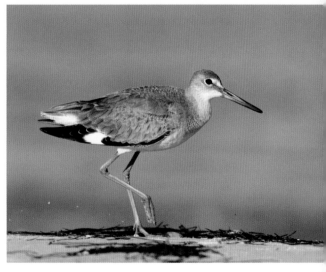

top—Willet asleep, horizontal image. When photographing a cooperative subject, capture horizontal and vertical images and be ready to get more shots when they wake up. This image was captured in Fort de Soto Park, one of Florida's bird photography hot spots. **bottom**—Willet walking along beach. I photographed it sleeping and waited for it to wake up for some action shots.

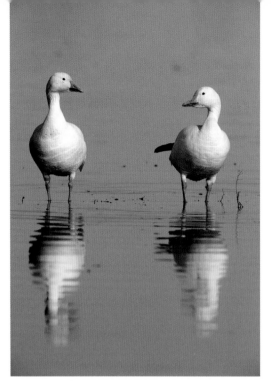
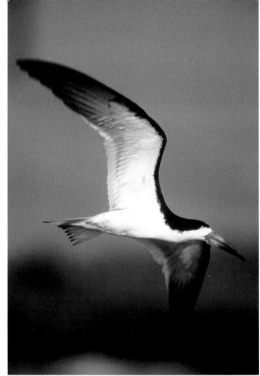

left—Snow Geese at Sacramento NWR, California. The refuge is a one-hour drive for me. **right**—Is this your backyard? It isn't mine, either. Black Skimmer in Brazil.

campgrounds, picnic areas, refuges, and zoos. Other captive locations can offer good photo opportunities, too. You won't know what you'll find unless you look. If there is a species you'd like to photograph or place you want to visit, look to the Internet for places where they will likely be found. The thrill of the search is half the fun, so get out and explore.

The following list is a sampling of what I like. I've also included some locations that friends have shared with me. The cool thing is, there is an endless array of great locations. My preference is to spend time in some of the less traveled spots; this gives me images that are unique and might stand out. But crowded places often have cooperative subjects, which makes photographing them easier.

A Few of My Favorites

- The Klamath Basin Wildlife Refuges in Northern California is a complex containing six refuges, and it's one of my favorite places to photograph birds. There are lots of acres and many birds. The highlights are the waterfowl that migrate through in fall and spring and the fact that it boasts the largest population of Bald Eagles in the lower 48 states during the winter. I love the spring and summer for photographing babies and nesting birds. There are tons of opportunities here, but it takes a couple of days to get into sync with the huge area, and the birds can be skittish. With hard work, the rewards will be many unique shots. The refuge offers numerous driving tour routes, photo blinds, and trails with a

diversity of habitats. I often shoot with no other photographers around.

- The Central Valley of California National Wildlife Refuge is another great option. There are wetlands with marsh species, and it's a hot spot for Ross' Geese as well as Snow Geese that winter in the area.
- The Bosque del Apache National Wildlife Refuge in New Mexico is a popular spot to photograph waterfowl and Sandhill Cranes. November into January are great times to visit.
- Magee Marsh in Ohio is a wonderful place to photograph migrants and warblers.
- Dauphin Island, Alabama, is a good location for photographing migrants.
- Pelagic trips off whatever coast you are near provide great photographic opportunities. Monterey Bay, California, offers some great birding trips for the pelagic or ocean-going birds.
- South Texas has many hot spots. South Padre Island in the spring can be amazing for migrants, and the beach species are used to people. There are some private ranches in South Texas that are set up with great feeding stations. You have to pay to go, but often will be in a blind with constant bird action.
- Kearney, Nebraska, is a spectacular place to photograph wintering Sandhill Cranes in the Platte River. There are photo blinds set up, and plenty of photo options along certain stretches of the river.
- Many grouse species can be found in the middle of the country, too. There are too many spots to list, but they are easy to

find on the Internet depending on your species interest. The Valentine NWR in Nebraska and the Selman Ranch in Oklahoma are two of my favorites.

- Florida is a great place to shoot, and there are many cooperative species—a fact that makes it much easier to photograph than some of the places in California. Getting out of your car in many California locales makes the birds fly away, so you have to work harder, be more patient, and maybe use a blind. In Florida, I can often get out of the car without the bird flying away. Rookeries of herons can be found in theme parks like Gatorland, St. Augustine Alligator Farm, and the Venice Rookery. Everglades National Park, especially the Anhinga Trail, is another choice location. Many cities and towns have small marshes with boardwalks that can be quite

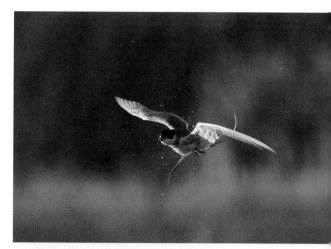

top—This image shows a Forster's Tern shaking off in mid flight in Klamath Basin, California. **bottom**—A flock of Red-Winged Blackbirds is a common sight in many Northern California refuges during winter.

productive. I like Wakodahatchee and Viera Wetlands. The town of Cape Coral has, it seems, Burrowing Owls nesting in every empty lot. The National Wildlife Refuges like Ding Darling, Merritt Island, and Loxahatchee are just the tip of the Florida iceberg. The only problem is, there *are* no icebergs—it is usually warm!

- Midway Island is one of those magical places, like the Galapagos Islands, where the birds are tame and unique. Tours are usually necessary for both places. There are hot spots in Alaska, too. I like the Pribilof Islands and Nome for nesting birds. If you are interested in rare migrants, then a trip to the end of the Aleutian Islands on Attu might be for you.

International Locations

Japan, Africa, Galapagos Islands, Falkland Islands, Antarctica, Australia, Brazil, Costa Rica, Panama, Ecuador, and Belize all offer amazing bird photography opportunities. Again, you'll find birds just about anywhere you go. Before you go, make sure your passport is up to date, and apply for a new one, if need be, a couple of months before your trip. It takes a while for a passport to be processed. Some countries require travel visas, immunizations, and some have fees. Be sure to check with the U.S. Department of State's Bureau of Consular Affairs. Their website, travel.state.gov, lists all of the countries' requirements.

top left—I am always looking for a storytelling shot. This poor Laysan Albatross got stuck in some wires on Midway Island. We helped rescue him after the shot was in the bag. **bottom left**—Ecuador is a bird photography hot spot. I photographed this Blue-Winged Mounain-Tanager flying down from a perch. **right**—Black Hawk from Costa Rica.

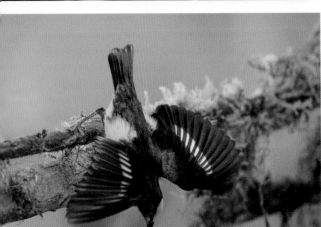

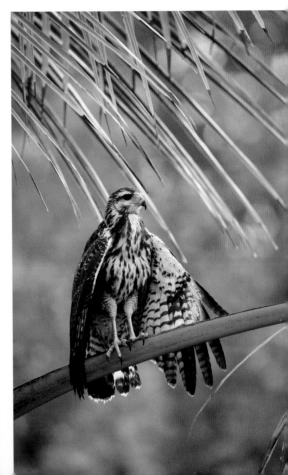

I often travel with my blind. You just never know when you might need it. This Gray Flycatcher nest was a lucky find, and I needed a blind.

I want to spend more time in Canada and have heard Churchill, Manitoba, is a hot spot. You can also find many other interesting places with a little research. Also, the nesting Gannets at Cape St. Mary's, Newfoundland, seem amazing. These are some of the places I am looking forward to photographing soon.

Travel Tips

If you are driving on a photo trip, take all your gear, including blinds and even feeder/water setup equipment. If you are flying, you will have to be more selective. What to take will depend on what you want to photograph. You'll also need to consider size and weight restrictions imposed by the airlines. Do your research on these issues before you pack. For air travel, I prefer to pack the majority of my equipment in a carry-on.

My laptop case is my personal bag. I fill it with as much stuff as possible, including the hard drives, card reader, and charger cords. Thank goodness the airlines haven't started weighing our carry-ons—my total

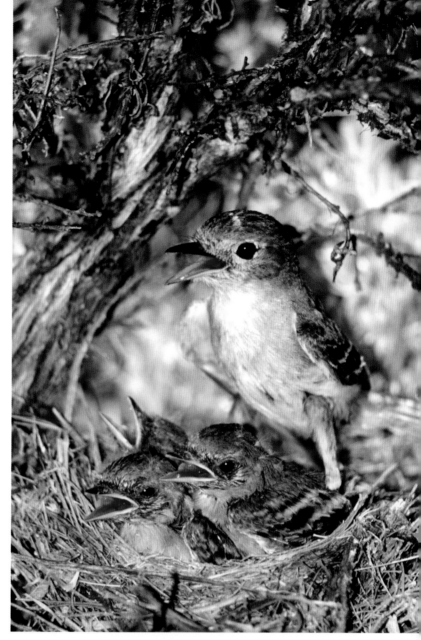

carry-on weight is close to 45 pounds. For many overseas flights, however, they weigh everything, even you!

My second carry-on bag is my Lowepro backpack. It holds my big lens, a body, and the other lenses I am taking. (Again, what I pack depends on where I am going and what I plan to shoot.) Zoom lenses are helpful if you need to save weight, as they

cover many focal lengths. The Lowepro backpack fits in most overheads, except on small planes, in which case I have to leave it at the bottom of the plane's stairs. I place a FRAGILE sticker on it and touch base with the bag handlers before I leave it. Sometimes I even ask if I can put it in the closet on board with the steward, although this is hit or miss depending on their mood and how full the flight is. On one flight on a smaller plane, the stewardess put it in a vacant seat with its own seatbelt. They aren't always as nice as she was.

In my checked bag is the tripod (the head is in my carry-on bag), any other things that might be deemed extras, blinds, and setup equipment. If my checked bags are lost or late, I will still be able to photograph because my carry-on contains all of the essentials.

Don't forget, you will also need to pack all of your personal items. I'm diabetic, so I keep those supplies with me at all times. It is important to carry on any medications and other essentials. I recommend that you bring prescriptions from your doctor and emergency contact numbers in case any unforeseen events occur on a trip.

Most importantly, remember to enjoy yourself. Just getting to your location is half the adventure. Be patient with all the travel and expect the worst delays. They usually don't happen, but anticipating them may help you relax.

Mallard with chick photographed from my floating blind. I have even taken my blind on a plane to Alaska. It isn't that heavy, but I did have to purchase the PVC pipes upon arrival. I don't travel with them because they are so long.

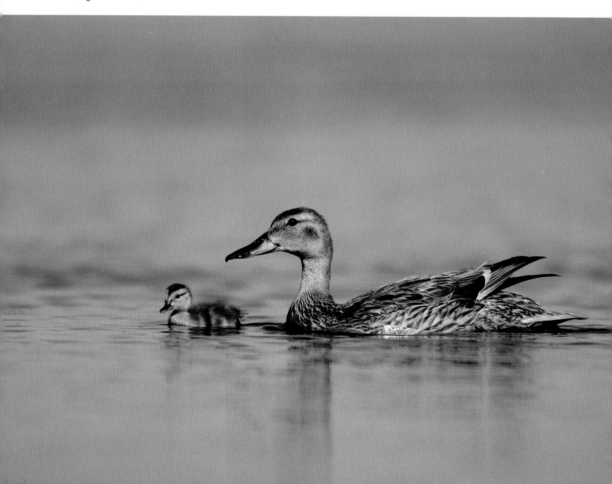

Now that you've captured and processed your images, what will you do with them? Working in the field is the real reward for some people. When they've gotten their images, they are content to share them with only friends and family. Others want to sell their pictures. Your choices at this stage are personal, but the amount of time and effort you will need to invest will depend on your intentions.

In the film days, I used to say I spent ten days in my office for every day I spent in the field. Today, it is probably more than that, but a lot can be done now while on location. Editing can be done in the field, and with a Wi-Fi connection, you can readily share your images on a number of sites on the Internet.

Online

Create your own website via a hosting site or hire someone to design and maintain a site for you. Having a website is validating and makes you look professional. You can feature your best work on your site, list the services you provide, and give people a way to contact you.

You can also share your images on photo-sharing websites (Flickr, Instagram, etc.) and perhaps offer them for sale. Many photographers use a Facebook page for their photography, and it is a great way to post your work online in a personalized way. It will also help build your client base and mailing list.

You can connect with other bird photographers on a blog or bird photo site, as well. You may find that other users will

top—My homepage. **bottom**—Here is the "buy my book" page on my website.

11. WHAT TO DO WITH YOUR PHOTOS

critique your work and offer constructive advice.

Editorial

Selling images for editorial use is an endeavor that yields little money these days. There are a couple of exceptions: *National Geographic* and *National Wildlife Federation* pay well. Many of the specialty publications that use bird photography are low paying. They have also started publishing readers' photos to save money. This may give you an opportunity to get published. Don't

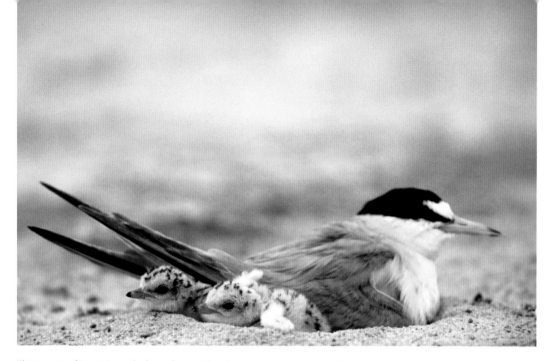

This image of Least Tern chicks in the nest has been used editorially. It tells a good story.

overlook the hunting magazines. They still pay and need bird pictures.

To work with a publication, first get a copy of their photographer's guidelines and follow them. Request their want list for each issue. It is not always easy to get on a publication's submissions list, but when you do, send only your best work. If you get a rejection letter, keep at it. Never give up.

One of the best ways to get a photo published is to write an article. I am a photographer first, but I've been doing more writing lately, and that increases the odds for photo sales. If you have another expertise besides birds, you can work that angle for your writing projects, too. Be sure to read the publication's writers' guidelines, which you will find on their website.

If you want to get your images in print and/or offered for sale, it's important to have a professional look about you, your

presentation, and your work. I have gone to bookstores and gift shops—and anyplace you can imagine that sells bird stuff. Once I find a company that buys bird photos, I will get the address and find the best way to approach them. If your photos are good, you can sell them. If your photos are great but never get marketed, you can't sell them. My motto is, if my photo isn't in the "mail," I can't sell it. Yes, my motto is out of date with the word "mail," but you get the point.

Most magazines have their own pricing schedule, and you will be in competition with other photographers, so you will have to negotiate your price. The reality is, if you won't "give" your photos away, there will be someone else willing to. Most professional bird photographers today aren't making much money with editorial sales.

Photo Tours

There is money in photo tours, and you will notice that everybody and their brother seems to lead one. If you are interested in going on a photo tour, there is a lot to be learned from good leaders and the others in the group. If you want to start leading your own photo tours, make sure you are proficient in your bird photography specialty. It's beneficial to be interested in teaching and helping others learn the craft. Many photo tours have leaders that will shoot right along with you. On other tours, the leader mostly helps clients. I recommend that you take a few tours before you start leading your own.

A good way to start a photo tour business is to offer one in your own "backyard"—a place in your general geographic location that you know inside and out. Choose a place with magnificent photo ops, and promote your tour using some of the incredible images you captured there. You might also consider leading a tour centered around mastering a specific technique, like photographing hummingbirds using multi-flash setups or using a floating blind. Once you start getting clients, you'll find your good work is rewarded with referrals and new clients.

Presentations

If you enjoy speaking or sharing your photos with a live audience, consider booking a lecture or workshop. Check into opportunities with the National Audubon Society's local chapters and other birding groups in your area. You might also look into presenting your skills at retirement homes, museums, schools, and photo groups. The opportunities are endless.

When making a presentation, keep it under 50 minutes long (or shorter, if their schedule demands it). I like to present my

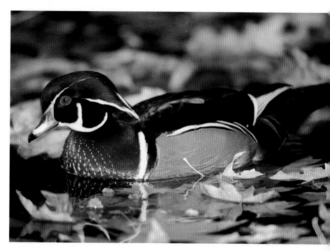

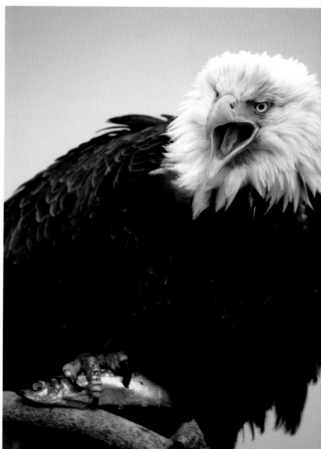

top—I photographed this Wood Duck swimming through leaves while leading one of my photo tours. **bottom**—Bald Eagle with a fish. Would this make a nice print? There probably aren't many people who would want to hang it on their wall, but it is a nice action shot. Eagles sell well if they look majestic.

work with a story or theme, and I often play music while a series of beautiful pictures is displayed on-screen. I use FotoMagico for my "slide shows"—I mean *presentations* (Sorry! It is hard to teach an old dog new tricks). This program offers many cool features and transition options, allowing you to create a professional look. Before the date of the presentation, be sure you have all of the details squared away. Will the venue provide the equipment you'll need? If so, practice and be sure you know how to use it.

Prints

Making prints is a time-honored way to share your work. The bigger the image, the more dramatic it will be. Whether you frame the print, mat it, or simply sell the print itself is up to you. There are many public places that would love to hang beautiful photos for free. If the facility or venue allows it, you can add your business card and a price tag. You never know—you might just make a sale.

Many people like to outsource their printing to a local lab, and that is what I do. Some photographers love to make their own prints, and that works for them. Whatever you choose, remember that quality is important, especially when it comes to making print sales. There are many galleries and venues for hanging your prints. Coffee houses and the like are often willing to hang a local artist's work. If you do your own framing and matting, you will save a lot of money. If you have someone else mat and print all your photos, be ready to spend some money. Pricing your work is tricky and will depend on the market you are in.

I know some photographers who travel and make a living selling their prints at craft fairs and art shows. Do some research to determine which ones might be a good fit for your work. Maybe sign up at a birding conference or festival to sell your prints. Festivals have popped up in many cities around the country and tend to be fun-filled weekend-long events. Check out the Winter

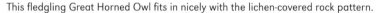

This fledgling Great Horned Owl fits in nicely with the lichen-covered rock pattern.

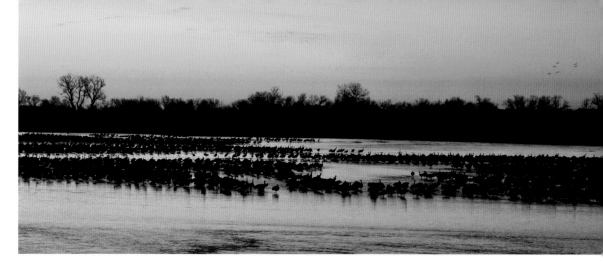

There is a nice Sandhill Crane festival in Kearney, Nebraska, called "Audubon's Nebraska Crane Festival." It is held in March.

Wings Festival in Klamath Falls, Oregon, and the Space Coast Birding and Wildlife Festival in Florida. Do a search and you will probably find a festival near you. If you are traveling to a new location to attend a bird conference, keep in mind that you might find new subjects to study and photograph.

In addition to selling your work, you might sign on to be a speaker or take a class and learn something new. It is fun to be surrounded by like-minded bird lovers, albeit not necessarily bird photographers. The festivals are usually held at great birding places during the peak of the bird activity. For example, a grouse festival would be held during the spring lekking time, and hummingbird festivals are typically held when the birds are most colorful. Some festivals are centered around one rare species. Port Aransas, Texas, has a Whooping Crane festival in February. I always enjoy myself, learn something, and take a few photos—and I love presenting programs at the festivals.

Donations for a Cause

This is wide open. You can give your time, photography, money, or whatever. Donating can make you feel good and can be a tax write-off. I like to give back to the people who have helped me find good photos. I will offer photos, monetary donations to their efforts, or take them out to lunch— whatever it takes to say "thanks for your help." There are so many outfits that would love to have your donations. I pick and choose the ones that are most important to me.

When you are putting your photos out there, you are putting yourself out there, too. Be sure to have thick skin. You will find people who aren't big fans and others who are. You can't please everyone all the time, and it isn't even worth trying. Just have fun. After all, that is the main reason we are photographing birds—or anything else for that matter! If you are passionate, diligent, and good, you will succeed.

Acknowledgments

I need to go back to my childhood to thank people—my parents, friends, and Boy Scout leaders—for my love of the natural world. My passion for photography started in 6th grade and has never waned. I am mostly self-taught but had a 9th grade photography teacher who taught me the basics. Thank you, Mr. Sihon. My college roommate, Mark Higley, and his dad, John, were instrumental in helping me get a foundation in wildlife photography. I feel like I'm getting an Academy Award, so I'll keep this short.

I have learned a lot and have a lot more to learn. Reading John Shaw's *The Nature Photographer's Complete Guide to Professional Field Techniques* in the 1980s put me on track for creating professional-quality images on a consistent basis. I sold my first photos to Rocky Mountain Elk Foundation for their magazine, *Bugle*. Shortly thereafter, I submitted photos to *Audubon*, and editor Les Line replied with a form letter that basically said "never send us photos again." So, I used what I learned in Shaw's book and resubmitted some bird photos. They were published in *Audubon* in 1987. Thank goodness Les had an openness about using great photos, no matter who took them, and I had a never-give-up attitude. I have since developed great relationships with many photo buyers, and I am grateful to each of them. My good friend, professional photographer Jeremy Woodhouse, helped me to elevate my work another notch a decade ago. He has a great eye, is a travel bug, and shared his creative vision.

My two boys have been a big help over the years—*and* great travel companions. They appear as youngsters in the book, but they are now grown up and graduated from college. We had fun back in the day, and we still take an annual trip together.

My mother, at the age of 86, is my biggest fan. My wife, Heidi, is the most supportive partner ever; she has given me endless love and her total support to write this book and continue my photography.

INDEX

Bald Eagles in the Wild
A VISUAL ESSAY OF AMERICA'S NATIONAL BIRD

Jeff Rich presents stunning images of America's national bird and teaches readers about its daily existence and habitat. $24.95 list, 7x10, 128p, 250 color images, index, order no. 2175.

Big Cats in the Wild

Joe McDonald's book teaches you everything you want to know about the habits and habitats of the world's most powerful and majestic big cats. $24.95 list, 7x10, 128p, 220 color images, index, order no. 2172.

Horses
PORTRAITS & STORIES

Shelley S. Paulson shares her love and knowledge of horses in this beautifully illustrated book. $24.95 list, 7x10, 128p, 220 color images, index, order no. 2176.

Dogs 500 POOCH PORTRAITS
TO BRIGHTEN YOUR DAY

Lighten your mood and boost your optimism with these sweet and silly images of beautiful dogs and adorable puppies. $19.95 list, 7x10, 128p, 500 color images, index, order no. 2177.

Owls in the Wild
A VISUAL ESSAY

Rob Palmer shares some of his favorite owl images, complete with interesting stories about these birds. $24.95 list, 7x10, 128p, 180 color images, index, order no. 2178.

Polar Bears in the Wild
A VISUAL ESSAY OF AN ENDANGERED SPECIES

Joe and Mary Ann McDonald's polar bear images and Joe's stories of the bears' survival will educate and inspire. $24.95 list, 7x10, 128p, 180 color images, index, order no. 2179.

Trees in Black & White

Follow acclaimed landscape photographer Tony Howell around the world in search of his favorite photo subject: beautiful trees of all shapes and sizes. $24.95 list, 7x10, 128p, 180 images, index, order no. 2181.

Rescue Cats
PORTRAITS AND STORIES

Susannah Maynard shares her favorite images and heart-warming stories about her subjects' journeys home. $19.95 list, 7x10, 128p, 180 color images, index, order no. 2183.

Wicked Weather
A VISUAL ESSAY OF EXTREME STORMS

Warren Faidley's incredible images depict nature's fury, and his stories detail the weather patterns on each shoot. $24.95 list, 7x10, 128p, 190 color images, index, order no. 2184.

The Frog Whisperer
PORTRAITS AND STORIES

Tom and Lisa Cuchara's book features fun and captivating frog portraits that will delight amphibian lovers. $24.95 list, 7x10, 128p, 180 color images, index, order no. 2185.